# PAINTING TOOLS & MATERIALS

*A practical guide to*

## PAINTS, BRUSHES, PALETTES
*and more*

Brimming with creative inspiration, how-to projects, and useful information to enrich your everyday life, Quarto Knows is a favorite destination for those pursuing their interests and passions. Visit our site and dig deeper with our books into your area of interest: Quarto Creates, Quarto Cooks, Quarto Homes, Quarto Lives, Quarto Drives, Quarto Explores, Quarto Gifts, or Quarto Kids.

Inspiring | Educating | Creating | Entertaining

Artwork and photographs on page 8 (top) courtesy of Martin Universal Design; pages 10 ("Taboret"), 18 ("Value," "Mixing"), and 87 © Joseph Stoddard; pages 4 (top), 16 (top), 17 ("Tubes," "Semi-Moist Pots," "Watercolor Pencils"), 18 ("Granulation"), 19-21, 22 (top), 23 (top), 24 (top), 26, 28-29, 30 (top), 31 (top), 32-33, 34 (top), 35, 36 (bottom right), 39 (top), 40, 44 ("Staining Test"), 45, 46-47, 50, 51 (top), 52-58, 63, 68 (except top), 69, 74, 80 (bottom), and 81 (top) © Elizabeth T. Gilbert; pages 16 (bottom right), 64-67, 70, 72, and 92-95 © Maury Aaseng; pages 22 (bottom) and 96-99 © Varvara Harmon; pages 23 (except "Basic Acrylics"), 24 (bottom images), 25, 27, 43, 68 (top), 78-79, 82-85, and 86 (top sequence) © Patti Mollica; pages 30 (bottom) and 104-109 © Jim McConlogue; page 36 (bottom left) courtesy of Vanessa Rothe; pages 39 (bottom) and 110-112 © Jennifer McCully; page 41 "Ribbon or Cord," "Yarn" © Cherril Doty & Marsh Scott, "Alcohol Inks" © Monica Moody, "Magazine Transfers" © Suzette Rosenthal, "Encaustic Paint" © Linda Robertson Womack, "Collage" © Cherril Doty and Susette Rosenthal; page 59 (bottom) © Helen Tse; page 60 ("Scumble," "Lifting Out") © Nathan Rohlander; pages 60 ("Blending") and 61 © WFP; page 62 © Lori Lohstoeter; pages 71 and 73 © Cherril Doty & Suzette Rosenthal; page 80 ("Classical Drawing") © Lance Richlin; page 81 (bottom) © Janice Robertson; page 86 (bottom sequence) © Peggi Habets; pages 90-91 © Paul Talbot-Greaves; pages 100-103 © Caroline Zimmermann. All other images © Shutterstock.

Thank you to H.R. Meininger Co. of Colorado Springs, CO, for allowing Walter Foster to photograph art materials, including their store interior (page 4), brushes (page 31, top), paints (page 34, top), painting knives (page 69), and many other tools.

First Published in 2017 by Walter Foster Publishing, an imprint of The Quarto Group. 6 Orchard Road, Suite 100, Lake Forest, CA 92630, USA. T (949) 380-7510 F (949) 380-7575 www.QuartoKnows.com

Walter Foster Publishing titles are also available at discount for retail, wholesale, promotional, and bulk purchase. For details, contact the Special Sales Manager by email at specialsales@quarto.com or by mail at The Quarto Group, Attn: Special Sales Manager, 401 Second Avenue North, Suite 310, Minneapolis, MN 55401 USA.

ISBN: 978-1-63322-282-3

Digital edition published in 2017
eISBN: 978-1-63322-456-8

Project editing and content development by Elizabeth T. Gilbert
Cover design and page layout by Melissa Gerber

Printed in China
10 9 8 7 6 5 4 3 2 1

FSC
www.fsc.org

MIX
Paper from
responsible sources
FSC® C104723

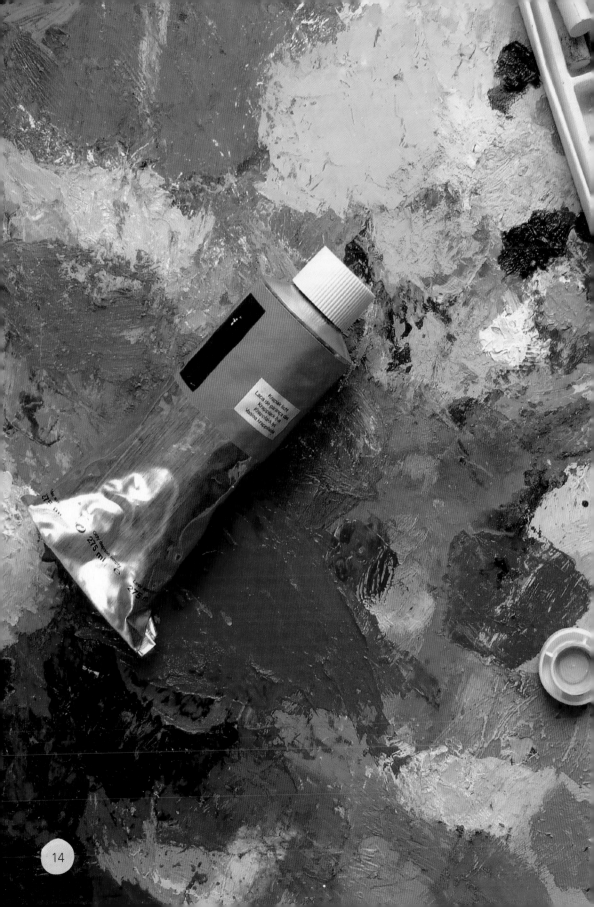

# Studio Safety

Painting involves materials that, when handled improperly, can be detrimental to our health and safety. From solvent fumes and flammability to pigment toxicity, there is plenty to consider while both planning a studio and painting. In general, store any liquids upright and secure their lids tightly. Also, avoid storing paints, oils, and solvents near heat.

Oil painting calls for a number of hazardous materials, so it's important to know safe handling habits before you begin. Below are guidelines to follow while using this medium.

- Work in a well-ventilated area, particularly when using paint thinners and harsh solvents such as turpentine. They release toxic fumes during use and as they evaporate from the drying paint.
- When paint-making or handling dry pigments, use a respirator mask, safety goggles, and rubber or vinyl gloves.
- Use rubber or vinyl gloves when handling solvents and paint. Consider using a barrier cream on your hands to reduce any potential absorption.
- Do not work near heat or flames. Solvents, especially turpentine, are highly flammable.
- Do not throw solvent-soaked rags into the trash due to their flammability.
- Do not pour paints or solvents down the drain. Contact local disposal companies or environmental government agencies to determine the best course of disposal.
- Do not pile up or throw oil-soaked rags into the trash. As they oxidize in open air, drying oils (particularly linseed) pose a risk of spontaneous combustion.
- Do not put your hands, brush handles, or other art materials in your mouth during a painting session. Also, avoid eating and drinking while painting.
- Know the ways toxins can enter the body: through ingestion, inhalation, and contact with the skin or eyes.

**For more on pigment safety, see page 44.**

# Introduction

Quaint art stores, welcoming studios, and blank canvases resonate with potential in the minds of artists. Whether you're a beginner new to the world of painting or a seasoned artist looking to brush up on basic knowledge, we're all connected by the excitement and intrigue we feel from the topic of art materials.

Today we have access to more supplies than ever before, whether we purchase at art and craft stores or through online retailers. As you develop your collection of art materials, it's a good idea to buy the best you can afford at the time. Higher-quality artist-grade materials are more costly than student-grade materials, but they contain less fillers, yield richer colors, afford the artist more control over the medium, and are less likely to fade over time. Purchasing high-quality materials from the start will likely save you frustration in the long run.

This book covers all the supplies involved in painting—from brushes and palettes to paint and supports. You'll also find ample information on setting up an effective studio, executing techniques, and understanding basic painting concepts and methods. The final chapter features six step-by-step projects in a variety of painting media, allowing you to practice your newfound knowledge of tools and techniques. Meet the contributing artists on the following page!

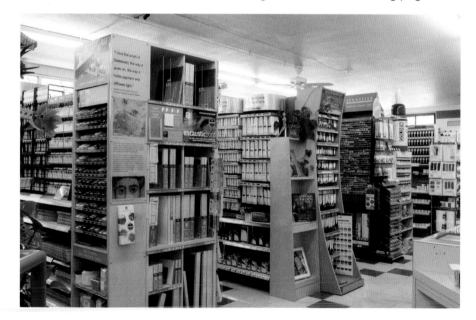

*Buying supplies online is convenient for purchasing some materials, but there's nothing like viewing and holding art materials in person at a local art and craft store. Photo courtesy of H.R. Meininger Co. in Colorado Springs, Colorado.*

# TABLE OF CONTENTS

# MEET THE ARTISTS

In 2004, **Maury Aaseng** began his career in freelance illustration in San Diego, where he created graphics for young-adult nonfiction. His work since then has expanded into instructional line-drawn illustrations, cartooning, medical and anatomical illustration, and more traditional media such as drawing and watercolor. He now lives in Duluth, Minnesota, with his wife and daughter.

**Varvara Harmon** of Windham, Maine, is an award-winning multimedia artist who has mastered oil, acrylic, watercolor, silk painting, and ink and pencil drawing. Her work has been juried into national and international exhibitions and is in private collections around the world. Varvara is a member of several artist organizations and has been featured in numerous publications. She teaches workshops and classes in acrylic, watercolor, and oil.

**Jim McConlogue** is a professional fine artist from Encinitas, California. He paints with oil, both *plein* air and at his home studio. Having studied life drawing, painting, and illustration through several notable schools and workshops, he has been featured in fine-art and instructional books, magazines, and newspapers. Jim currently works on commissioned paintings, and his original oils and giclée prints are displayed at galleries in Leucadia and La Jolla, California.

**Jennifer McCully** is a graphic designer who unleashed her creative spirit to include mixed media work. Her endless creativity can be seen on her bold canvases, which feature vibrant and simple objects that are energetic and inspiring. Her childlike creations evoke happiness, and her inspiration is drawn from practically anything. Jennifer is a full-time Etsy seller and the author of *There are No Mistakes in Art*.

**Patti Mollica** lives and works with her fellow-artist and jazz musician husband, Mark Hagan, in New York City and Nyack. An impressionistic and contemporary painter, she believes that a painter's job is to show the viewer the inherent beauty of all subjects and scenes. She has been selected by Golden Paints to conduct lectures and facilitate workshops demonstrating "Creative Techniques Using Golden Paints and Mediums."

**Paul Talbot-Greaves** is a professional watercolor and acrylic landscape painter from the UK. A member of several art societies and panels, Paul has written for *The Artist* magazine and published several instructional art books. His work often depicts rugged scenery, crumbling walls, ancient pastures, and moorland terrain.

**Caroline Zimmermann** began painting in oils at age 6, earned her Bachelor of Fine Arts in Illustration from California State University, Fullerton in 1989, and obtained her Master of Fine Arts in Painting from the California College of the Arts and Crafts in Oakland in 1994. Her permanent residence is in the artists' community of Laguna Beach, where she has lived, surfed, and painted for more than 30 years. She now divides her time between her home in Laguna Beach and her studio in Tuscany.

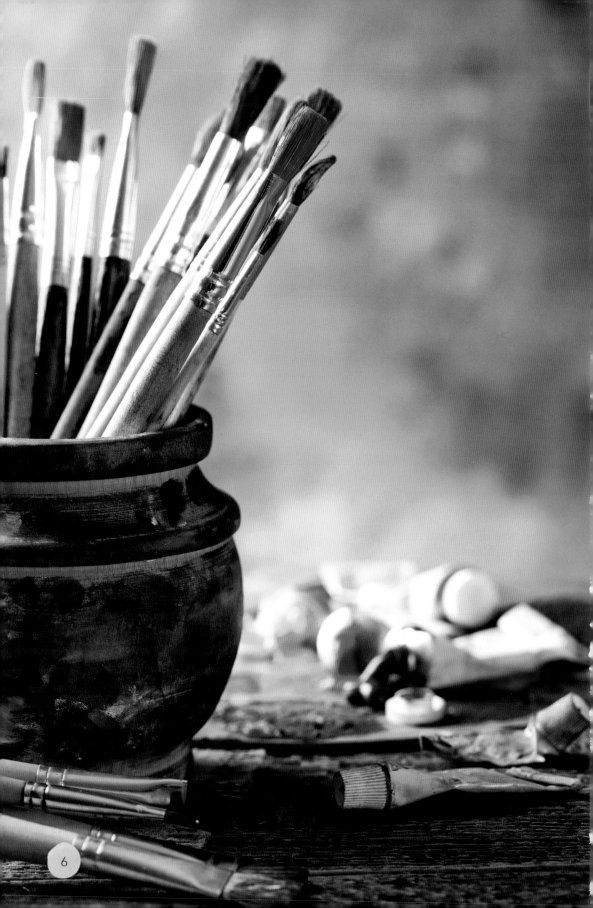

# CHAPTER 1:
## Studio & Storage

An efficient studio or workspace can make all the difference for an artist. A well-designed space can help you stay organized, tidy, and comfortable—and it can simplify the artistic process by providing good lighting and effective working surfaces. A studio doesn't have to be its own room; you can create a workspace anywhere in your home or garage. This chapter covers the following topics:

- Easels and Working Surfaces
- Tool and Equipment Storage
- Lighting and Comfort
- Studio Safety

# Easels & Working Surfaces

Your working surface should depend on your chosen medium. For artists working in watercolor, a flat or slightly tilted surface works best, whereas easels are the traditional choice when working in oil or acrylic.

## SURFACES FOR WATERCOLOR

Watercolor artists often work on flat, smooth surfaces, such as tables or simple desks. Some choose to work on craft or drafting tables, which allow users to tilt the surface to varying degrees. (However, watercolor artists avoid steeply angled surfaces to prevent unwanted drips and runs.) Drafting tables are often made of wood, composite wood, or tempered glass and have ledges or compartments for holding art materials. Many also feature wheeled legs and drawers for storing supplies.

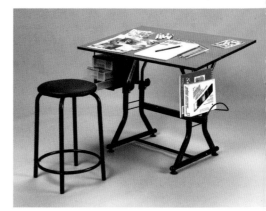

*Shown above is one option of many craft tables available from Martin Universal Design.*

## STUDIO EASELS

Studio easels are sturdy, freestanding canvas supports. Traditionally they are made of wood, but you can also find lighter-weight metal varieties. Studio easels often fold flat so you can tuck them away into a corner of the studio if needed.

*An A-frame easel is perhaps the most common format. The main frame, shaped loosely like an "A," is supported by a third leg.*

*An H-frame easel is a classic format that can support large canvases. A tiltable main frame is anchored to a small base.*

## PORTABLE EASELS

Also called a French easel, a box easel is a great option for artists who work outdoors. This portable unit collapses into a compact box and features a handle for easy toting. The easel has three adjustable legs supporting a wooden box that holds materials; the lid serves as a tiltable canvas support with a ledge.

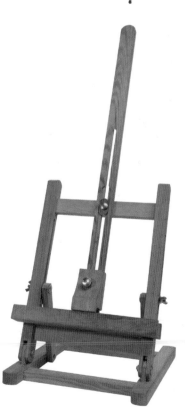

*Box easel, open and ready for painting*

*Box easel, closed and ready for traveling*

## TABLETOP EASELS

This type of easel sits atop any flat surface and holds your work upright as you paint. They are usually mini H-frames or mini A-frames in format. Tabletop easels are sometimes used to display finished artwork on desks or countertops.

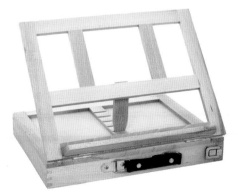

*Box-style tabletop easel*

*Standard H-frame tabletop easel*

# Tool & Equipment Storage

Keep your materials organized and easy to access using some of the storage options shown on the following two pages. This will not only help your efficiency as an artist, but it will help you keep your working surfaces free of clutter so you can move freely and focus on painting.

## TABORET

A taboret is a small storage unit with cupboards, drawers, trays, or shelves for holding art materials. Taborets can double as tabletops; artists can use them to support a palette, brushes, and mediums while painting.

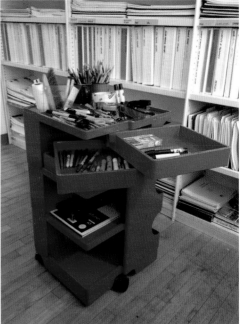

*A taboret includes several compartments in a compact space. The unit often features wheels so you can easily move it around a studio, keeping your materials close and organized.*

## POCHADE BOX

Pochade boxes (or wooden art boxes) are available in a range of sizes and shapes. They often come with dividers that create compartments for storing art materials. Some are available with removable trays that allow you to stack layers of tools.

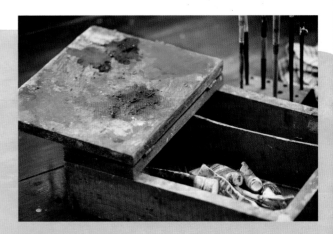

*Featuring handles and clasps to secure the lids shut, pochade boxes can be used both for storage in the studio and for painting off-site.*

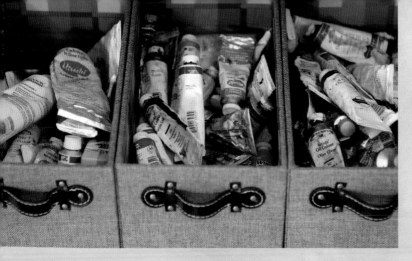

## BINS AND DRAWERS

Plastic bins and old drawers are great open-topped storage options that keep tools categorized while offering easy access. These affordable organizers can be found at dollar stores and thrift stores.

*Simple drawers lined along shelves are handy for categorizing paint tubes.*

## STORING ARTWORK

An art studio is more than a workspace; it can be a safe place to store finished work. Below are a few guidelines for creating optimal conditions.

- The environment should be cool, dry, and inhospitable to mold (for the sake of both your artwork and your art materials).

- Store dried watercolor paintings in short stacks, separated by acid-free tissue paper. Large, wide, shallow drawers or cupboard shelves are great for this.

- Canvases and frames should be stored vertically to save space and protect them from any scratches and pressure from stacking. Wrap canvases with plastic to prevent dust from settling on the paint.

# Lighting

Good lighting is an essential element in an effective art studio. Traditionally, the best lighting for artwork is plentiful natural light coming from the north. This shows color and values in their truest forms, prevents rays of light from falling directly on the work, and reduces eyestrain for the artist. An ideal studio features large, high north-facing windows.

Artists who don't have the option of north light or who work at night must use artificial lighting to illuminate their workspaces. There are myriad possibilities for lighting a studio; ultimately, personal preference will guide the way. Below are a few points to remember when setting up your studio lighting:

- **Temperature:** The light in your studio should be neutral in color, so avoid a setup that leans too cool or too warm. Some artists use a combination of incandescent and fluorescent bulbs, while others rely solely on daylight simulation bulbs.
- **Direction:** Most professional studios feature both general overhead lighting as well as task lighting, which focuses light on a smaller workspace. Position both types of lighting in a way that avoids creating shadows of your hand across your work.

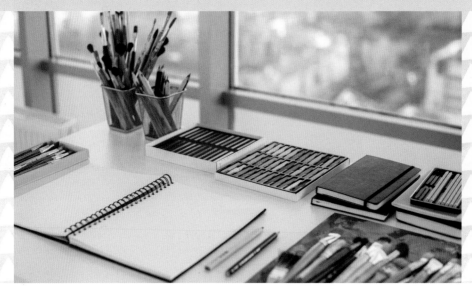

# Comfort

Comfort may seem like a luxury in a workspace, but it is critical to artistic success. Art takes time—sometimes much more than planned—and you must make efforts to keep yourself physically capable of the task at hand. Keep your studio at a reasonable temperature, and consider opening a window for fresh air and ventilation. Choose a padded chair with adequate back and arm support. Finally, think about adding music to your space for relaxation or extra inspiration.

# CHAPTER 2:
## Paints & Mediums

Paint is the vehicle through which you carry your subject, message, and emotion in a painting. Knowing how to select and use the best paint for the job is crucial to your success as an artist. But paint is just a fraction of the process; you'll also need to acquaint yourself with the mixing surfaces, brushes, supports, and other supplies that work best with your paint of choice. This chapter lays out this information for you while covering the following categories of art supplies:

- Watercolor
- Acrylic
- Oil
- Other Paints
- Mixed Media
- Pigments

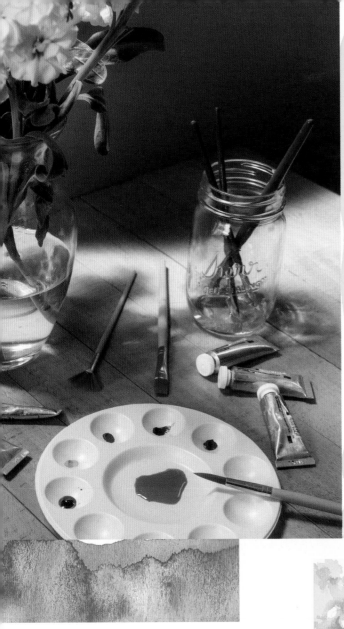

# WATERCOLOR

The airy and atmospheric qualities of watercolor set it apart from all other painting media. Made up of pigment suspended in a binder of gum arabic, watercolor is a fluid medium that requires quite a bit of practice to master. However, if you devote enough time to this medium, you'll understand why it is treasured for its ability to quickly capture an essence, suggesting form and color with just a few brushstrokes.

To re-create this watercolor painting by artist Maury Aaseng, turn to page 92!

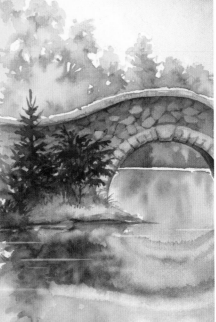

# WATERCOLOR PAINTS

Watercolor is pigment dispersed in a vehicle of gum arabic (a binder), glycerin (a plasticizer to prevent dry paint from cracking), corn syrup or honey (a humectant to keep the paint moist), and water. Fillers, extenders, and preservative may also be present. Watercolor comes in four basic forms: tubes, pans, semi-moist pots, and pencils. What you choose should depend on your painting style and preferences.

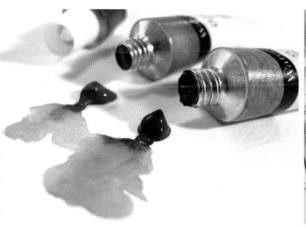

**Tubes** *Tubes of watercolor contain moist paint that is readily mixable. Unlike oil and acrylic, you need only a small amount of paint to create large washes. Start with a pea-sized amount, add water, and then add more paint if necessary.*

**Pans** *Pan watercolors, also called "cakes," are dry or semi-moist blocks of watercolor. Many lidded watercolor palettes are designed to hold pans, making them portable and convenient. To activate the paint, stroke over the blocks with a wet brush.*

**Semi-Moist Pots** *Semi-moist pots of watercolor are the most economical option. The colors sit in round pots, often in a row with a lid that serves as a mixing tray. These watercolors are formulated with more humectant to retain moisture. Activate by stroking over the pots with a wet brush.*

**Watercolor Pencils** *These tools combine the fluid, colorful nature of watercolor with the control of pencil drawing. The pencils feature leads of hard watercolor that you can sharpen. You can apply them with a dry tip on wet paper or with a wet tip on dry paper; you can also apply a dry tip on dry paper, followed by strokes of a wet brush.*

# WATERCOLOR PROPERTIES

The unique properties of watercolor paint determine how it behaves on the surface. Although you will learn plenty through careful experimentation, it's a good idea to keep the properties below in mind before you begin. (You'll also want to acquaint yourself with the specific properties of your pigments; see pages 42–47.)

**Value** Watercolor relies on the white of the paper beneath to tint the layers above it. Because of this, artists lighten a watercolor mix by adding more water and increasing transparency—not by adding more paint.

**Granulation** Some watercolors feature pigment particles that are large enough to settle into the grooves of watercolor paper, creating a mottled appearance. Common granulating pigments include ultramarine blue, viridian, cobalt violet, and burnt sienna. In contrast, many modern pigments feature very small particles that produce smooth, even washes.

**Mixing** The more pigments added to a mix, the less light will show through the paint. For this reason, it is wise to limit the number of pigments you use to create watercolor mixes. Many artists work with a limited palette (or a limited number of colors) to keep their color mixes fresh. Some artists prefer to mix their washes in a palette before applying them to the paper, whereas other artists allow the paints to intermingle on the paper, creating interesting edges and blends. At right you can see examples of both methods.

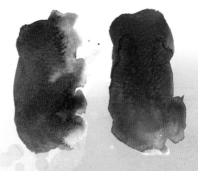

*Ultramarine blue and alizarin crimson mixed in the palette before applying to the paper (left) and mixed directly on the paper (right).*

# WATERCOLOR MEDIUMS

Watercolor mediums and additives alter the characteristics of the paint. Whether you want more flow, gloss sparkle, or texture, a number of products are available to help you achieve your desired results.

**Gum Arabic** Made from the sap of an acacia tree, gum arabic is the binder of watercolor paint. When added to your jar of clean mixing water, it increases the gloss and transparency of watercolor.

**Ox Gall** Ox gall is made of alcohol and cow bile. The medium is a wetting agent that increases the fluidity of watercolor. Add just a few drops to your jar of clean mixing water to see the effects.

**Iridescent Medium** This medium gives a metallic shimmer to watercolor paint. Mix a small amount into your washes, or stroke the medium directly over a dried wash.

**Granulation Medium** When used in place of water in a watercolor wash, this medium encourages granulation and creates a mottled appearance within a wash.

**Lifting Preparation Medium** This medium allows you to lift watercolor from the paper—even staining pigments. Apply the medium to the paper with a brush and let it dry; then stroke over the area with watercolor. After the paint dries, use a wet brush to disturb the wash and dab the color away.

**Masking Fluid** Masking fluid, also called "liquid frisket," is a drying liquid, such as latex, that preserves the white of the paper while you paint over it. Once the paint is dry, you can rub away the frisket to reveal the paper beneath.

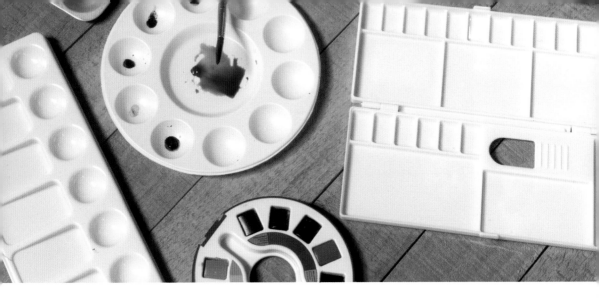

# WATERCOLOR PALETTES

Due to watercolor's fluid nature, mixing palettes for watercolors feature wells or pots to keep colors separated. The following palettes are the most commonly used by artists; however, shallow dishes and paper cups can work in a pinch!

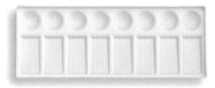 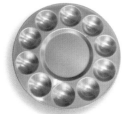 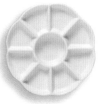

**Welled Palettes** Simple welled palettes are widely available in white plastic, ceramic, and uncoated aluminum. White allows artists to judge their paint colors as they'll appear on white paper, while aluminum offers a bright, reflective surface that is durable, rust resistant, and easy to clean. White plastic palettes are economical, easy to clean, and lightweight, whereas porcelain palettes are sturdier and resist beading on the surface. Some palettes also feature rectangular wells that are slanted for better pooling.

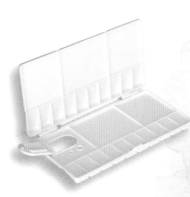

**Travel Palettes** Travel palettes are portable, compact palettes that fold and snap shut for painting on the go. The palettes open to reveal several wells for holding pan or wet paint straight from the tube, as well as areas for mixing.

**Potted Palettes** These palettes come with a number of lidded pots that line mixing wells. The pots keep water-based paints—such as watercolor, gouache, and acrylic—moist and ready to mix. They also prevent paint from spilling during travel.

## WATERCOLOR BRUSHES

Watercolor brushes are generally made from animal hair or synthetic fibers designed to deliver a consistent flow of pigment to your paper. Quality brushes should come to a fine point with hairs that spring back into shape after each stroke. Sable-hair brushes are considered the best choice for watercolor, as these hairs hold a good amount of fluid and  allow you to paint without having to frequently reload your brush. Watercolor brushes have short handles and are available in a variety of shapes and sizes. A good starter set of watercolor brushes might include a selection of rounds, a flat, a wash, a filbert, a fan, and a liner. For more on brush care, hair, and shapes, see Chapter 3.

## WATERCOLOR SUPPORTS & SURFACES

Watercolor paper is designed to accept the fluid washes of watercolor. This sturdy paper is treated with "sizing"—usually gelatin or animal glue—which helps the paper from absorbing too much moisture, giving artists control over their washes and minimizing buckling. Watercolor paper comes in single sheets, pads, blocks, and boards and is available in three textures: hot-pressed (smooth), cold-pressed (irregularly textured), and rough (rough with a deep tooth).

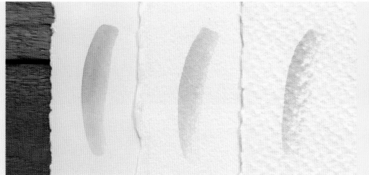

*A stroke of watercolor shown on hot-pressed paper (left), cold-pressed paper (center), and rough paper (right).*

## ADDITIONAL SUPPLIES

In addition to the tools mentioned, you'll need to gather a few more materials before beginning with watercolor. Many of them you'll find around the house! Below is a quick list:

- A jar of clean water for adding to your mixes
- A jar of water for rinsing your brushes
- Paper towels, rags, and sponges
- Pencil for sketching
- Artist's tape (for securing paper to your painting surface)
- Absorbent tools such as sponges, cotton balls, and cotton swabs

# Acrylic

Acrylic is a versatile paint that has become a respected medium for the fine artist only within the last century. Sharing qualities of both oil and watercolor paint, acrylic is a fast-drying, water-based medium that can be applied thickly in bold strokes or thinly in delicate washes. A growing number of exciting mediums are available to help artists alter the paint to their liking, including gels and pastes that change the consistency, texture, and sheen of the paint.

To re-create this acrylic painting by artist Varvara Harmon, turn to page 96!

## ACRYLIC PAINTS

Acrylic paint is made up of pigment suspended in a binder of acrylic polymer emulsion. It is water-based, so you can dilute the paint with plain water—no need for harsh solvents! This paint dries quickly to a waterproof finish and has shown great resistance to cracking and fading. Acrylic comes in a variety of storage containers, including tubes, tubs, jars, and squeeze bottles. Manufacturers offer the paint in the main categories featured below:

**Basic Acrylics** The most common acrylics available have less body than oil paint but much more than watercolor washes. The gel-like consistency forms soft peaks and offers a great middle ground for artists who desire more control than fluid paints without the bulk of thick, heavy paints.

**Heavy Body Acrylics** Heavy body paint is characterized by an exceptionally smooth, thick, buttery consistency. These paints have the ability to "stand up" and retain brushstrokes or palette knife marks, and they remain extremely flexible when dry.

**Fluid Acrylics** Bearing the consistency of heavy cream, fluids are self-leveling and do not retain brushstrokes. When mixed with medium or water, they make brilliant glazes and washes. Because it is waterproof, this paint can be layered without disturbing what's underneath, provided you let each layer dry before adding the next.

**Acrylic Inks** These very fluid paints are the thinnest acrylics available. They work well with watercolor techniques, such as spattering and glazing, and they can be used with an airbrush or technical pen.

**Iridescent Acrylics** Iridescent acrylics contain mica, which gives them a metallic shimmer. Iridescent paints are very reflective and create exciting accents, depth, and variation.

**Interference Acrylics** When painted over a dark background, these transparent paints shimmer brilliantly. When painted over a light-colored background, its complementary color will appear. This fascinating "flip" effect of interference paints occurs when light waves are reflected and refracted. (In this example, the paint appears purple over black and yellow over white.)

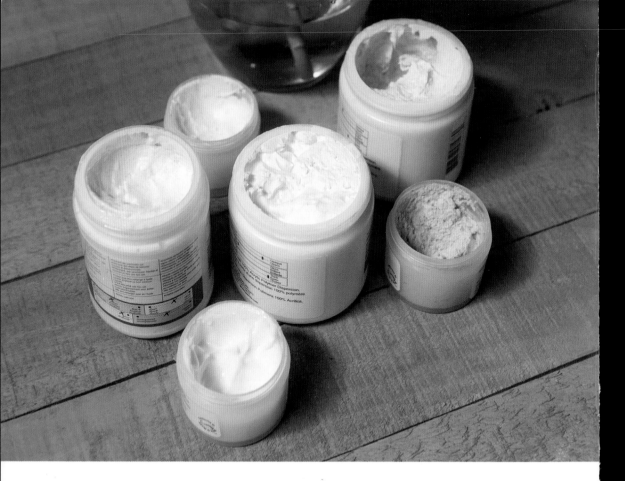

# ACRYLIC MEDIUMS AND ADDITIVES

Acrylic is gaining popularity in the fine art world, and some of the credit must go to the growing array of gels, pastes, and additives that allow you to alter the paint to your liking. Interesting textures, sheens, and consistencies are now easy to achieve.

You can use all gels and pastes in the following ways: as a surface texture on which to paint (called a "ground"), mixed with paint for added body, fluidity, or a change in sheen (called a "medium"), and applied on top of your painting for a covering effect.

*Fluid paint used as a wash applied to a fiber paste ground.*
*A few drops of fluid paints swirled into soft gloss gel allows the colors to glide and create beautiful patterns.*
*Glass bead gel applied in a thin coat over dry colors produces a frosty, shimmery effect.*

Light Molding Paste

Clear Tar Gel

High Solid Gel (Matte)

Coarse Pumice Gel

Regular Gel (Matte)

Crackle Paste

Coarse Molding Paste

Clear Granular Gel

Extra Heavy Gel (Gloss)

Heavy Gel (Gloss)

Soft Gel (Matte)

Glass Bead Gel

Molding Paste

Fiber Paste

Self Leveling Clear Gel

Other notable mediums for acrylic include retarders, which extend the drying time of acrylic and increase the flow of the paint. They allow more time for blending, glazing, and creating fine detail.

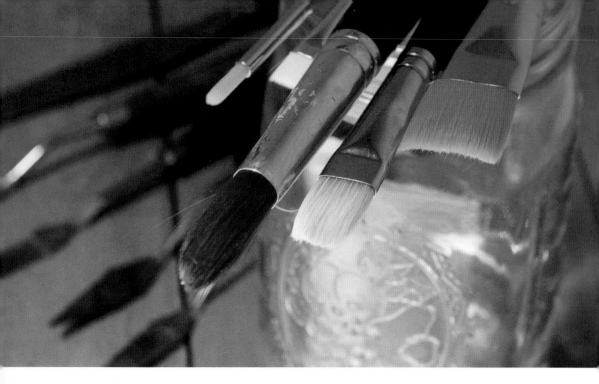

## ACRYLIC BRUSHES

Synthetic brushes are considered the best choice for acrylic paint, as the caustic nature of acrylic can damage more fragile natural hairs. Also, the hardier synthetic brushes can withstand more submerging in water. Made of nylon or polyester, synthetic brushes can either feature very soft hair or stiff, coarse bristles. Soft brushes are best for smooth strokes and details, whereas stiff bristles produce bolder strokes with texture.

Acrylic brushes come in both long and short handles. Long handles are great for easel work, when your hand works at a distance from the canvas. Short handles are better for details and working in a style that involves thin washes or glazes.

When using acrylic, it's important to keep in mind that paint dries quickly—and when it dries, it is waterproof and hard. Therefore, thoroughly rinse each brush before switching to a different one during a painting session. Never let a brush sit in open air for long while it contains paint. At the end of a session, wash the hairs or bristles with mild soap and warm water. Gently pinch out excess water, reshape, and lay flat to dry.

For more information on brushes, see Chapter 3.

## PALETTE AND PAINTING KNIVES

These tools feature handles and thin, flexible metal blades for mixing, applying, and scraping away paint. The blade can either be flush with the handle or slightly bent away, and it can vary widely in shape and size. Inexpensive plastic painting knives are also available. For more on palette and painting knives, see pages 68–69.

# ACRYLIC SUPPORTS

Acrylic paint needs a "toothy," porous, absorbent surface to which it can bind and adhere. For this reason, many surfaces need to be primed first to accept the paint. The most common primer (or ground) is acrylic dispersion ground (also called polymer "gesso"). Below are the most popular acrylic painting supports.

**Canvas** Canvas can be purchased primed or unprimed, as well as unstretched in large rolls, pre-stretched on wooden frames, or mounted on panel boards. To prepare unprimed canvas, apply two coats of gesso; let it dry, and then apply another coat perpendicular to the strokes of the first layer.

**Canvas Paper** This commercially prepared paper simulates canvas texture and weave but is available in pad form. It doesn't require priming and is less expensive than actual canvas.

**Paper and Boards** Many artists paint on watercolor paper, print-making papers, and Bristol board. You can use these surfaces either primed or unprimed. To minimize buckling and warping of paper, tape the sides down to a stable surface, wet the entire paper, and let it dry completely. This "pre-stretches" the paper so that it retains its flat quality when you paint on it.

**Cardboard and Mat Boards** These surfaces are economical, lightweight, and readily available. Many framers will freely give you their leftover mat board scraps if you ask. Prime with two coats of gesso before using.

**Hardboard and Panels** Many artists paint on smooth, hard surfaces, such as hardwood (oak, cedar, birch, etc.); medium density fiberboard (MDF), such as Masonite; and plywood. These surfaces contain resins and impurities that can leach into your painting, so they need to be primed with acrylic polymer medium.

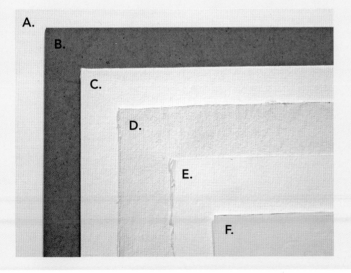

As long as a surface is primed, it can hold acrylic paint. Some artists work on plastic, stone, or metal sheets such as aluminum and copper. When working on smooth surfaces, you may need to score the surface before priming to make sure it adheres properly. Clear acrylic dispersion ground works well as a primer when you want to maintain the color or luminosity of the original painting surface.

**Traditional painting surfaces:**

**A.** *Canvas paper*
**B.** *Masonite or hardboard*
**C.** *Pre-primed canvas panels*
**D.** *Canvas*
**E.** *Watercolor paper*
**F.** *Primed mat board*

## ACRYLIC PALETTES

Paint palettes offer handy surfaces for mixing paints and mediums. Acrylic palettes are available in a variety of sizes, shapes, and materials, including plastic, plexiglass or tempered glass, and coated paper. During a painting session, remember that acrylic dries quickly; it's helpful to have a spray bottle on hand to occasionally spritz water over the paint on your palette.

**Plastic Palettes** These smooth, lightweight, and inexpensive mixing surfaces are available in an assortment of sizes and shapes, from handheld to tabletop varieties. They can be simple and flat or feature wells for separating thin, watery mixes. Clean them easily using soap, warm water, and a scrubbing sponge.

**Clear Palettes** These palettes are sheets of plexiglass or tempered glass. They're sturdy, smooth, and easy to clean with soap and warm water. To view your mixes over various values and colors, you can simply slip toned papers beneath.

**Palette Paper** Disposable sheets of palette paper are poly-coated for a smooth, moisture-resistant surface. Work directly on the pad and tear off the sheet when finished, or begin by placing a clean sheet on a flat surface (such as an old baking sheet).

## SEALED TRAYS

Many artists use shallow, airtight container for storing their palettes. You can use the plastic bottom directly for mixing paint, but most artists use the containers to store disposable or handheld palettes. When using these trays for acrylics, seal the tray with a wet sponge inside to create a moist environment; otherwise the paint will dry quickly. There are a few "stay wet" palettes for acrylic on the market that come with a wet sponge component.

# OTHER SUPPLIES

In addition to the acrylic supplies mentioned, you'll want to gather the following items:

**Pencil or Marker** You can use pencil or waterproof marker to sketch on your support before painting. However, plan on using marker only if you plan to layer your paint in a way that will ultimately cover the lines.

**Glass Jars** Glass jars of varying sizes are handy for holding water for mixing and cleaning brushes.

**Rags & Paper Towels** Have these on hand for cleanup and correcting mistakes in your paintings.

**Mild Soap** You can wash your hands, brushes, and acrylic palettes using mild soap and warm water.

**Spray Bottle** A spray bottle of water is a useful tool for cleanup, keeping paints moist on the palette, and creating special effects in your artwork.

**Artist's Tape & Clips** Mildly tacky artist's tape and clips will help secure paper to a painting surface. To remove the tape from paper, pull it gently away from the edge at a 90-degree angle.

**Sponges** Sponges are helpful for cleanup, but you can also use them to apply paint to your artwork. Dab them to create mottled textures, or use them to create smooth washes. (For more on working with sponges, see page 71.)

**Cotton Balls & Swabs** These absorbent tools are helpful for wiping and lifting away paint. You can also use them to apply paint to your support.

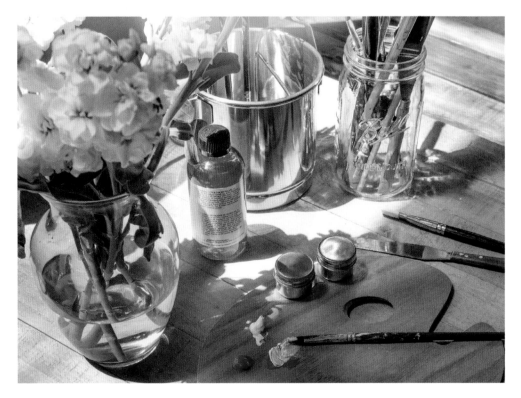

# Oil

This classic painting medium has dominated the world of fine art for centuries. Made of pigment suspended in oil, this paint traps light and creates a luminous effect on the canvas. The slow-drying properties of oil allow artists to create smooth blends and rework their paintings over multiple sessions, making it possible to achieve rich layers and realistic details. Because it's not water-based, you'll need special liquids for thinning the paint and cleaning your brushes. You'll also need to take safety precautions such as working in a well-ventilated workspace. (See page 13 for more on safety.)

*To re-create this acrylic painting by artist Jim McConlogue, turn to page 104!*

## OIL PAINTS

Oil paints consist of ground pigments suspended in an oil, such as linseed (most common), walnut, poppyseed, or other oils. You can use drying oils or resins mixed with solvent to change the properties of the paint, building up a lustrous painting from thin initial washes of color to thick, dimensional highlights. The oil dries to a tough but flexible film and protects the pigments to create long-lasting works of art.

Unlike watercolor and acrylic paint, oil takes a very long time to dry; it can take several days for a layer of paint to feel dry to the touch. Before applying varnish (a protective final coat), allow an oil painting to dry for at least six months. Be sure to keep a wet oil painting protected as it dries by storing it out of the way in a dark room.

*Oil paints are available in metal tubes. It's a good idea to purchase a larger tube of white, as you will use this paint in mixes more than any other color.*

# SOLVENTS

Solvents are liquids that break down the oil paints, allowing artists to thin the paint. Solvents are also essential for cleanup. (Remember: oil and water don't mix!) Solvents must be stored in appropriate containers; they often come in metal tins with a tight-locking screw cap. Four main types of solvents used for fine art are listed below.

**Turpentine** This toxic, flammable, colorless, and strong-smelling pine resin efficiently thins and dissolves oil-based paints and resins. Its fast evaporation rate helps artists advance the painting process.

**Mineral Spirits** This petroleum-based solvent is slightly less toxic, less flammable, and gentler on the skin than turpentine. It evaporates more slowly from paint.

**Odorless Mineral Spirits** This solvent features reduced toxicity and odor.

**Citrus-Based Solvents** This option is the least toxic of the four mentioned; however, its mild nature makes it less effective when working with resins.

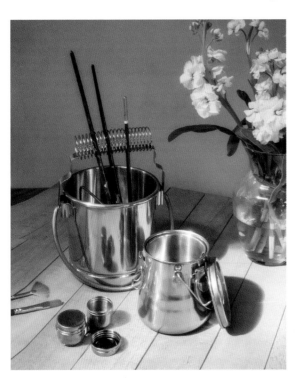

*Metal brushwashers are convenient for cleaning your brushes during a painting session. These containers hold a screen or coil near the bottom. Simply pour a small amount of solvent into the can (enough to rise above the screen) and run your brushes across the screen or coil to dislodge the paint. Some brushwashers (such as the one shown at left) feature a handle-like coil that allows your brushes to stand in the solvent without pressure on the hairs or bristles.*

**!** Solvents are toxic and flammable. Use them only in a well-ventilated area away from any source of heat, and dispose of them properly. For more on safety, see page 13.

## OIL MEDIUMS

Mediums allow artists to change the consistency and reflective qualities of the paint. Although you can technically paint straight from the tube, most artists add medium to extend the paint and build up an oil painting in layers. The word "medium" within oil painting generally refers to a mix of oil and solvent, with the solvent accelerating the drying process. Common oils and mediums include the following:

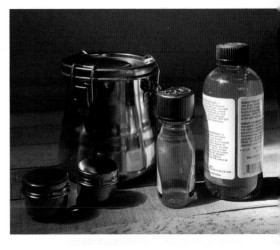

**Linseed Oil** This oil is the most commonly used oil in both paints and mediums. Pressed from flaxseed, it is slightly yellow in hue and increases the paint's gloss, flow, and transparency. It also slows the drying time of paint and dries to a tough film. Linseed oil is available in several varieties, each with different properties—including refined (thin and slow-drying), cold-pressed (fast-drying), stand (slow-drying, glossy, and viscous), and sun-treated varieties.

**Alkyd Medium** This contains resins that halve the drying time of paint and dry to a durable, flexible film.

**Stand Linseed Oil** *Stand oil's thick and slow-drying qualities make it ideal for the upper layers of an oil painting. Use it for luminous glazes and finishing touches.*

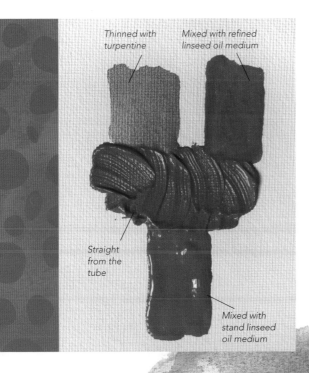

Thinned with turpentine

Mixed with refined linseed oil medium

Straight from the tube

Mixed with stand linseed oil medium

**Copal Medium** This resin speeds the drying time of paint while increasing flow and glass; however, it is prone to darkening.

**Damar Varnish Medium** This gloss-increasing medium is generally used in a ratio of one part damar varnish to one part turpentine to one part linseed oil.

## OIL BRUSHES

Three main types of brushes are used for oil painting: bristle, sable, and synthetic. Bristle brushes are made from hog hair, are very durable, and last a long time. Sable brushes are made from weasel hair and are very soft. They are not inexpensive, but they are strong and will stand up to your paints and give you a smooth stroke. Synthetic brushes are more affordable, but make sure they are designed for oil paints; this paint requires a brush that will stand up to its heavy body. Bristle brushes are best for creating textured strokes, whereas sable are best for flat, smooth strokes. Be sure to clean your brushes well after each painting session.

All brush types are available in a range of sizes and shapes. For more information on brushes, see Chapter 3.

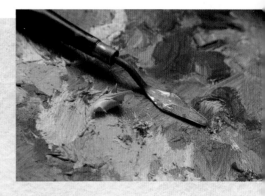

## PALETTE AND PAINTING KNIVES

Although many artists use brushes to mix small amounts of paint, a palette knife features a thin, flexible metal blade and is convenient for mixing and scooping large quantities of paint on your palette. Painting knives, which can also be used for mixing, are designed to apply paint to the support, creating bold, angular strokes. For more on palette and painting knives, see pages 68–69.

# OIL SUPPORTS

The surface you paint on is called the "support." You can apply oils to just about any kind of support—canvas, glass, canvas paper, canvas board, study papers, wood, hardboard (such as Masonite), and even metal. Simply make sure the surface is coated with few coats of a primer (such as polymer "gesso") to give the oils something to stick to and to prevent the paint from shrinking, peeling, or cracking. Ready-to-use canvases are either cotton or linen mounted on heavy cardboard or prestretched and stapled to wood frames, and they are available in a variety of sizes and textures. The texture—called the "tooth"—can range from a fine, dense weave (which is smooth) to a coarse, loose weave (which is rougher with more texture).

A: Sturdy papers

B. Pre-stretched and primed canvas

C. Primed canvas boards

D. Poplar panel

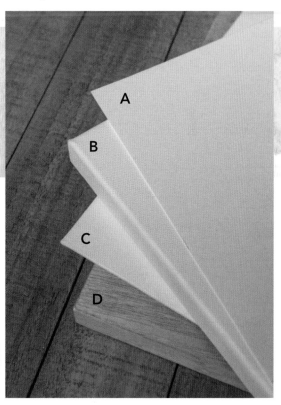

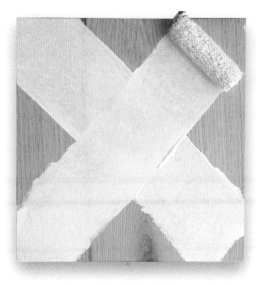

*When priming wood or hardboard, paint an "X" on the back to prevent warping. For even more stability, you can prime all of the edges and the entire back surface.*

# OIL PALETTES

Oil paints can be mixed on wood, plexiglass or tempered glass, or palette paper. The traditional choice is a handheld wooden palette, which provides a warm midtone surface to help you better assess paint colors. Many artists opt for a plexiglass or tempered glass palette, which is easy to wipe clean. With this type of palette,

you can easily alter its color or value by slipping sheets of toned paper beneath. Poly-coated palette paper offers a convenient disposable option. If you plan to return to an in-progress palette, store your palette in a sealed box or tray to protect the paint from dust. The paint should stay wet for a few days.

*Artists generally set up their palettes by placing paints in color wheel order around the palette edges. This leaves the center free for mixing and adding medium.*

*These small metal containers, which clip to the edge of a palette, keep oil mediums conveniently close while color mixing.*

## OTHER SUPPLIES

**Old Clothes or an Apron** Wear comfortable clothes that you don't mind getting paint on, such as old T-shirts. An apron that covers your chest and lap is another good option. Some watercolor and acrylic paints can wash out, whereas oil paints won't. (If you do get some oil paint on your clothes, try rubbing it with disinfecting wipes while the paint is still wet.)

**Pencil or Marker** You can use pencil or waterproof marker to sketch on your support before painting. However, plan on using marker only if you plan to layer your paint in a way that will ultimately cover the lines.

**Rags & Paper Towels** Have these on hand for cleanup and correcting mistakes in your paintings.

**Artist's Hand Soap** There are a variety of soaps on the market designed to clean hands after using oil paints. Many artists use baby oil or vegetable oil to remove paint from their hands before washing with soap and water.

**Artist's Tape & Clips** If using canvas paper, mildly tacky artist's tape and clips will help secure it to a painting surface. To remove the tape from paper, pull it gently away from the edge at a 90-degree angle.

**Sponges** Sponges are helpful for cleanup, but you can also use them to apply paint to your artwork. Dab them to create mottled textures, or use them to create smooth washes. (For more on working with sponges, see page 71.)

# VARNISHES

Varnishes are final layers (or "top coatings") designed to protect paintings from dust, scratches, and moisture. Some also offer protection against UV rays, preserving the intensity of a painting's colors. Varnishes also unify a painting's sheen. Varnishes are generally natural or synthetic resins and are available in brush-on and spray formats. The most common choice of traditional oil painters is damar (or dammar) varnish, which is a high-gloss natural resin that can be thinned only with turpentine.

# More Paints

**Gouache** Gouache is also called "opaque watercolor," as it is a highly pigmented version of watercolor with larger pigment particles and a chalk additive. This paint has an opaque sheen and a soft, flat appearance that lends itself well to graphic work. It can be applied thinly in the style of watercolor or thickly to celebrate its opaque qualities—and many artists use both washes and thick, textured highlights to create paintings with depth. Gouache is often tinted with white gouache for lighter, softer tones, and it works well on toned supports.

A B C

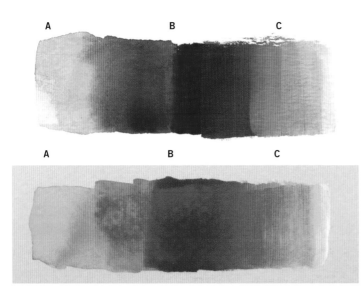

A B C

*Altering Gouache*
*Shown is magenta gouache thinned with water (A), in pure form (B), and lightened with white gouache (C) on both white and toned surfaces.*

**Tempera** Egg tempera paint is pigment mixed with water and an egg yolk binder. This type of paint pairs best with a rigid support such as wood panel. Ready-to-use egg tempera paints and mediums are not available at every art & craft store, so artists often make their own. (Note that some products labeled "tempera" in the store are actually poster paint—a mix of pigment and adhesive.)

**Encaustic** Encaustic painting involves painting with hot, colored, liquid wax. This challenging art form calls for numerous and costly tools, but it yields expressive, luminous, and often otherworldly results. Be sure to learn about any safety issues associated with encaustic, as it requires the handling of hot tools. (To view an encaustic technique, see page 41.)

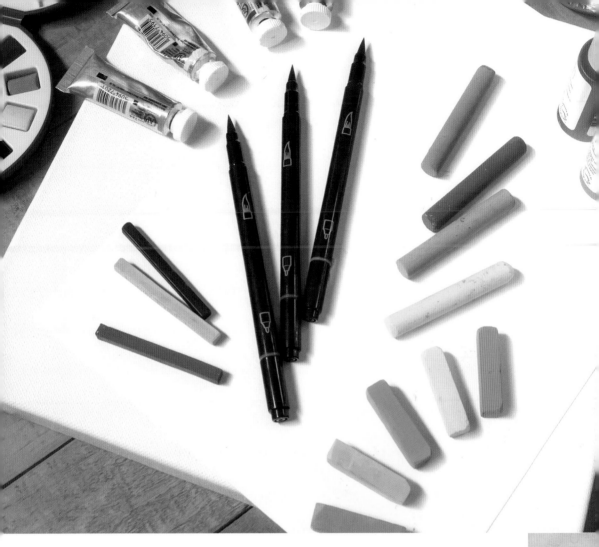

# Mixed Media

The term "mixed media" covers a wide range of styles and art materials. From combining traditional media, such as watercolor and pastel, to working with paper collage and found objects, the world of mixed media is teeming with possibility. On the following pages, learn about successfully combining traditional media, discover new materials, and view finished mixed media works to absorb ideas and inspiration.

*To re-create this acrylic painting by artist Jennifer McCully,* *turn to page 110!*

# COMBINING TRADITIONAL MEDIA

Although mixed media feels like an invitation to combine anything and everything, you'll find that some media are not technically compatible with others. For example, acrylic paint does not adhere to oil paint. Below is a general chart that will help you determine how to successfully approach mixed media with traditional tools.

## MEDIUM COMPATIBILITY

| | |
|---|---|
| **Graphite** | • Often used as a sketching tool under any dry or wet media.<br>• Can be applied over dried watercolor. |
| **Charcoal** | • Can be applied over dried watercolor.<br>• Can be used alongside Conté crayon and chalk pastel.<br>• Often used as a sketching tool under oil or acrylic (particularly vine charcoal). |
| **Chalk Pastel** | • Can be applied over watercolor, gouache, and dried acrylic. |
| **Oil Pastel** | • Can be applied over dried watercolor, gouache, and acrylic.<br>• Can be used alongside and over oil paint. |
| **Watercolor** | • Often paired with indelible ink for sketching.<br>• Can be used alongside and under gouache.<br>• Can be used as a ground for oil, acrylic, chalk pastel, and oil pastel. |
| **Acrylic** | • Can be applied over watercolor.<br>• Can be used as a ground for oil paint. |
| **Oil** | • Can be applied over dried watercolor and acrylic. |

# WORKING WITH UNCONVENTIONAL MEDIA

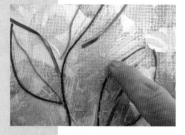

**Ribbon or Cord** Use ribbon or cord to create dimensional outlining. Wet the cord to make it malleable, and press it in place over an acrylic gel-coated surface. When dry, coat the entire piece with gel to keep it in place.

**Yarn** Create a textured ground by coiling and winding yarn designs over a rigid, acrylic gel-coated surface. Use a large brush to coat the yarn design with clear gel or polymer gesso, and allow to dry before painting over it.

**Alcohol Inks** These highly pigmented, fast-drying inks work well on non-porous surfaces such as glossy paper, glass, plastic, and metal. Tilt your surface as you apply them to create movement and interesting blends.

**Magazine Transfers** Coat your surface with acrylic soft gel and place a magazine image facedown. Smooth it with a credit card and let it dry. Then lightly sand the image and spritz with water before rubbing with your fingers to remove the paper.

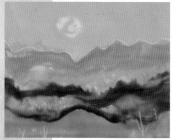

**Encaustic Paint** Encaustic paint is a mixture of beeswax, resin, and pigment. You can use it to make paintings with a buttery softness—or use it to collage with wax instead of glue. Heat the paint to about 200 degrees Fahrenheit and apply with natural-bristle brushes.

**Collage** Use acrylic matte medium on a soft acrylic brush to adhere a variety of papers to your surface, from magazine clippings and old music scores to tissue and specialty papers. You may want to seal the surface of your work with a layer of the matte medium, as it will dry clear.

# Pigments

Pigments are small particles that give paints their color. During paint production, the pigment is dispersed in a medium for flow, such as oil, gum arabic, or acrylic polymer. The pigments are evenly distributed and suspended (not dissolved) in the binder. Pigment particles either absorb or reflect rays of light, giving them their particular color. For example, a green pigment reflects yellow, green, and blue light rays while absorbing all others. The following pages discuss the main categories and properties of paint pigments.

**Inorganic vs. Organic Pigments** There are two basic pigment types: inorganic and organic. Inorganic pigments (such as yellow ochre and ultramarine blue) come from the earth or are manufactured from non-carbon substances. Synthetic organic pigments (such as phthalocyanines and quinacridones) are laboratory-created carbon compounds. Sometimes called "modern pigments," they are often more intense than inorganic pigments.

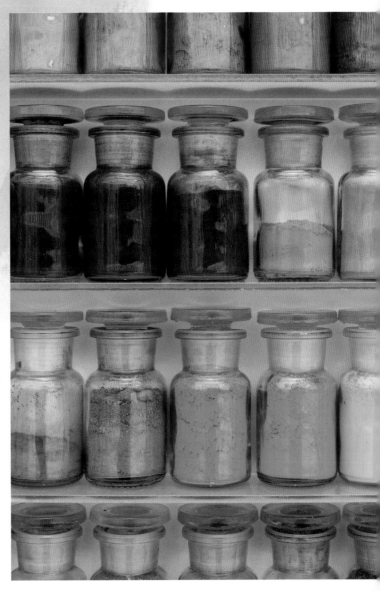

**Transparent vs Opaque** Pigments are categorized as either transparent, semi-transparent, semi-opaque, or opaque. Opaque pigments more effectively block light from hitting the surface beneath, whereas transparent pigments allow light to pass through and reflect the surface back to the viewer. Opaques provide more coverage and appear to advance toward the viewer, making the best for foreground objects and highlights. Transparents create luminous and atmospheric effects in paintings, making them ideal for glazes and shadows with depth.

**Tinting Strength** When using pigments with a strong tinting quality, a little goes a long way. Knowing the tint strength is helpful when mixing colors, strong tinting paints can overpower those with weak tinting strength, so you may have to adjust your mixes accordingly.

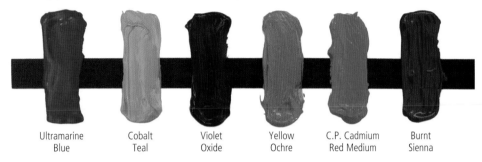

| Ultramarine Blue | Cobalt Teal | Violet Oxide | Yellow Ochre | C.P. Cadmium Red Medium | Burnt Sienna |

*Inorganic pigments are generally opaque with low chroma (vibrance) and low tinting strength.*

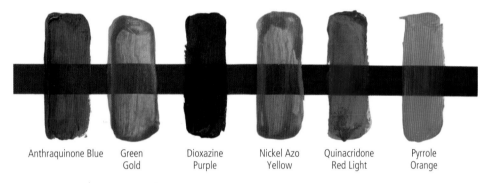

| Anthraquinone Blue | Green Gold | Dioxazine Purple | Nickel Azo Yellow | Quinacridone Red Light | Pyrrole Orange |

*Organic pigments are generally transparent and vibrant with high tinting strength.*

**Lightfastness** Lightfastness refers to the ability of pigment to resist fading over time, particularly when exposed to ultraviolet (UV) light. Lightfast pigments are not prone to fading and are considered to be more permanent than nonlightfast pigments. Nonlightfast (or "fugitive") pigments lighten and lose their intensity quickly. The American Society for Testing and materials (ASTM) has a rating system for lightfastness, which is printed on a color's tube.

## ASTM LIGHTFASTNESS SCALE

ASTM I: Excellent
ASTM II: Very Good
ASTM III: Fair
ASTM IV: Poor
ASTM V: Very Poor

**Staining vs Non-Staining** These pigment categories are most relevant to watercolor, as this medium calls for techniques that involve lifting or moving pigments once applied to the paper. Staining pigments, such as alizarin crimson or the phthalocyanines, immediately absorb into the paper's surface and are impossible to lift or dab away completely. Nonstaining pigments, such as burnt umber and the cadmiums, sit on the paper's surface and lift away easily.

## STAINING TEST

To test the staining quality of a paint, apply a rich stroke of the color to paper and allow it to dry. Then use a wet brush to loosen an area of pigment and dab with a paper towel. The more color that remains, the higher the staining quality. Above is a staining test performed on phthalo blue (staining) and burnt umber (nonstaining).

## PIGMENT TOXICITY

Some paint colors contain toxic metals, so it's important to handle them with care. Limit contact with your skin and eyes, and avoid inhaling or ingesting them. Below are a few paints with toxicity levels that call for consideration as you paint, with the offending ingredients in parentheses. Remember: If a paint name contains the word "hue," it is most likely a nontoxic substitute for the original pigment.

**!** **PAINT TOXICITY**

- Cadmium red, yellow, and orange (cadmium)
- Cerulean blue (cobalt)
- Chrome green, yellow, and orange (chromates and/or lead)
- Cobalt blue, green, violet, or yellow (cobalt)
- Emerald or Paris green (copper acetoarsenite)
- Flake white (lead)
- Manganese blue and violet (manganese)
- Naples yellow (lead and antimony)
- Vermilion (mercury)
- Zinc sulfide white (zinc sulfide)
- Zinc yellow (chromate)

## PIGMENT VARIATION

Manufacturers offer "hue" varieties of popular paint colors, especially in student-grade paint lines. A hue paint is not made purely of the pigment specified in the name; instead, it is a mixture of other pigments to match the hue of the original. Manufacturers do this to reduce cost, use pigments that are more readily available, reduce toxicity, or offer a better lightfastness rating. When mixing a hue paint, experiment and get to know its properties, as it can behave differently than its pure pigment counterpart.

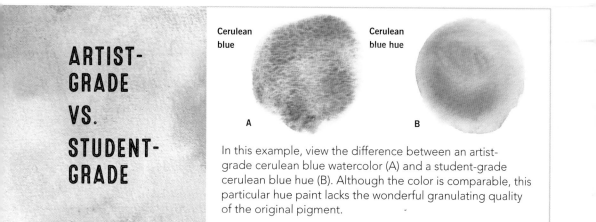

## ARTIST-GRADE VS. STUDENT-GRADE

Cerulean blue

Cerulean blue hue

A

B

In this example, view the difference between an artist-grade cerulean blue watercolor (A) and a student-grade cerulean blue hue (B). Although the color is comparable, this particular hue paint lacks the wonderful granulating quality of the original pigment.

In an effort to standardize pigment and dye colors within and across industries, the Colour Index International came to be in 1925. This database offers a solid reference; every pigment has been assigned a CI (Color Index) number, which is based on its chemical makeup. This allows artists to look beyond proprietary names and better understand the properties of their paints.

| | |
|---|---|
| Alizarin crimson | Pigment Red 83 |
| Cadmium red | Pigment Red 108 |
| Cadmium yellow | Pigment Yellow 35 |
| Cobalt blue | Pigment Blue 28 |
| Dioxazine violet | Pigment Violet 23 |
| Ivory or bone black | Pigment Black 9 |
| Lemon yellow | Pigment Yellow 3 |
| Mars black | Pigment Black 11 |
| Phthalo blue | Pigment Blue 15 |
| Phthalo green | Pigment Green 7 |
| Quinacridone magenta | Pigment Violet 19 |
| Raw and burnt siennas | Pigment Brown 7 |
| Raw and burnt umbers | Pigment Brown 7 |
| Ultramarine blue | Pigment Blue 29 |
| Viridian green | Pigment Green 18 |
| Yellow ochre | Pigment Yellow 43 |

## COMMON COLOR INDEX NUMBERS

# PIGMENT CHART

| Swatch | Paint/Pigment Name | Color | Pigment Type | Transparency | Staining Ability | Lightfastness (ASTM) |
|---|---|---|---|---|---|---|
| **REDS** | | | | | | |
| ● | Alizarin crimson | blue-leaning red | organic | transparent | high | II or III |
| ● | Cadmium red | yellow-leaning red | inorganic | opaque | low | I |
| ● | Quinacridone red | blue-leaning red | synthetic organic | transparent | high | I |
| ● | Naphthol red | yellow-leaning red | synthetic organic | semi-opaque | high | I |
| ● | Perylene red | slightly blue-leaning red | synthetic organic | transparent | medium | I |
| ● | Pyrrole red | yellow-leaning red | synthetic organic | semi-opaque | high | I |
| **PURPLES** | | | | | | |
| ● | Dioxazine purple | blue-leaning violet | synthetic organic | transparent | high | I |
| ● | Quinacridone violet / Quinacridone magenta | red-leaning violet | synthetic organic | transparent | medium | I |
| **BLUES** | | | | | | |
| ● | Ultramarine blue | red-leaning blue | inorganic | semi-transparent | low | I |
| ● | Phthalo blue | yellow-leaning or red-leaning | synthetic organic | transparent | high | I |
| ● | Manganese blue | yellow-leaning blue | inorganic | transparent | high | I |
| ● | Cobalt blue | slightly yellow-leaning blue | inorganic | semi-transparent | low | I |
| ● | Cerulean blue | yellow-leaning blue | inorganic | semi-transparent | low | I |
| **GREENS** | | | | | | |
| ● | Phthalo green | blue-leaning green | synthetic organic | transparent | high | I |
| ● | Cobalt green | yellow-leaning green | inorganic | semi-transparent | low | I |
| ● | Terre verte | olive green | inorganic | transparent | low | I |
| ● | Viridian | blue-leaning green | inorganic | transparent | low | I |

| Swatch | Paint/Pigment Name | Color | Pigment Type | Transparency | Staining Ability | Lightfastness (ASTM) |
|---|---|---|---|---|---|---|
| **YELLOWS** | | | | | | |
| | Aureolin | primary yellow | inorganic | transparent | low | II |
| | Hansa yellow / Lemon yellow | bright blue-leaning yellow | synthetic organic | semi-transparent | low to medium | II |
| | Nickel azo yellow | brownish yellow | synthetic organic | transparent | medium | I |
| | Cadmium yellow | red-leaning yellow | inorganic | opaque | low | I |
| **EARTH COLORS** | | | | | | |
| | Burnt sienna | red-leaning brown | inorganic | transparent | low | I |
| | Burnt umber | red-leaning brown | inorganic | transparent | low | I |
| | Raw sienna | yellow-leaning brown | inorganic | transparent | low | I |
| | Raw umber | varied; often gray- or green-leaning brown | inorganic | transparent | low | I |
| | Yellow ochre | orange-leaning yellow | inorganic | opaque | low | I |
| **BLACKS** | | | | | | |
| | Ivory or bone black | warm black | inorganic | semi-transparent | high | I |
| | Mars black | cool black | inorganic | opaque | high | I |
| **WHITES** | | | | | | |
| | Titanium white | blue-leaning white | inorganic | opaque | N/A | I |
| | Zinc white / Chinese white | blue-leaning white | inorganic | semi-opaque | N/A | I |

Note: The colored circles shown are for illustrative purposes only. Actual paint colors may not match exactly due to variations in printing ink.

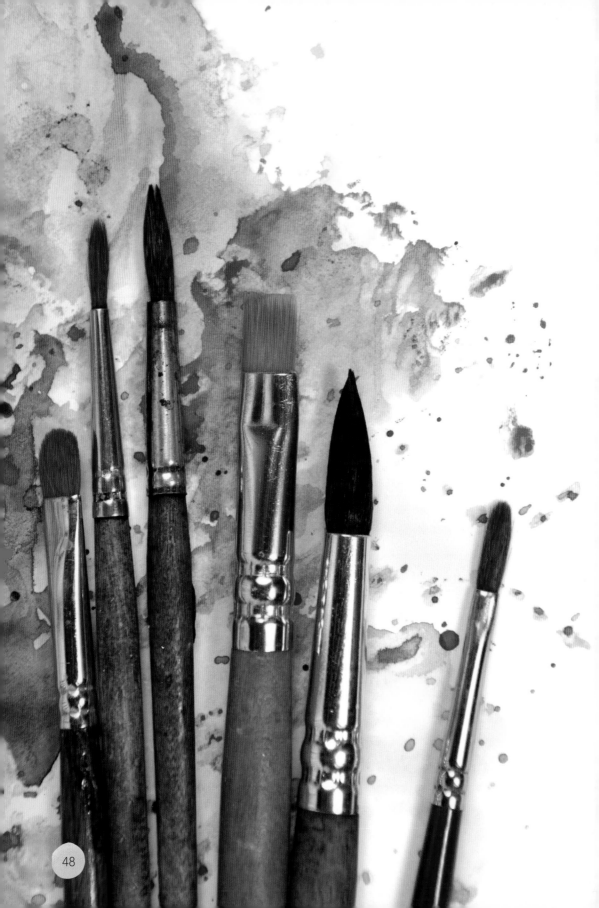

# Chapter 3:

## Brushes & Techniques

To understand the importance of brushwork, think of a painting as a song. The paint acts as the voice, and the brushstrokes act as the notes that express the melody. Learning the appropriate brush to use for the job, along with the most effective techniques, is necessary for delivering your desired message. This chapter covers the following topics:

- Brush Hair Types
- Brush Anatomy
- Brush Care
- Brush Shapes
- Brush Techniques
- Additional Painting Techniques

# Brush Hair Types

Brushes come in three main hair types: natural, synthetic, and bristle. Natural-hair brushes are made up of the soft hair of an animal, such as a squirrel or mongoose. Synthetic-hair brushes are made up of man-made fibers, such as nylon and polyester filaments. They are ideal for acrylics and work well with watercolor. Bristle brushes are technically "natural" as they are made of hog hairs, but the hairs are coarse and sturdy making them ideal for working in oil and heavy-bodied acrylic. Each bristle has a natural split end or "flag" that helps the brush hold paint for good coverage.

Below are the most common types of animal hairs used for brushes, along with their characteristics.

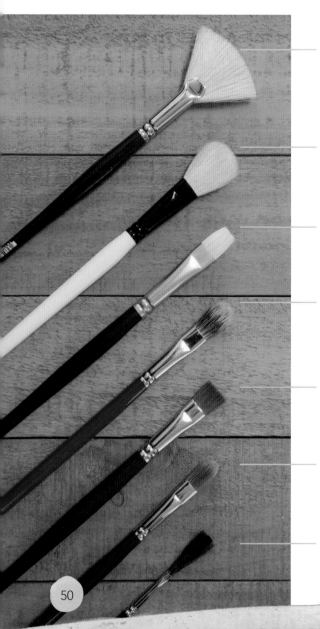

**Hog bristle:** coarse hairs with flags that carry a good amount of paint.

**Goat:** soft hairs that perform best with fluid media.

**Hog bristle:** coarse hairs with flags and naturally curved bristles that create tapered points.

**Mongoose:** sturdy but soft hairs for controlled strokes with any paint.

**Sable:** soft, resilient hairs that hold a large amount of moisture.

**Ox:** soft, fine hairs, from the ears of oxen used in flat and blended-hair brushes.

**Squirrel:** absorbent hairs with low resilience that work best with fluid media such as ink.

# Brush Size & Anatomy

Brushes are labeled by size on the handle. Round brushes are generally given a number between 000 (very small) and 24 (very large). Sizing is inconsistent between brands, but sizes 6 to 10 are often in the medium-sized brush range. Flat brushes are measured by width in inches or millimeters.

Made of wood or plastic, brush handles vary in length based on the intended medium. Long-handled brushes are intended for use with oil or acrylic; they are designed to be held horizontally while working at a distance on a vertical canvas. Short-handled brushes are intended for use with watercolor, ink, and other fluid media that call for a flat or slightly tilted working surface.

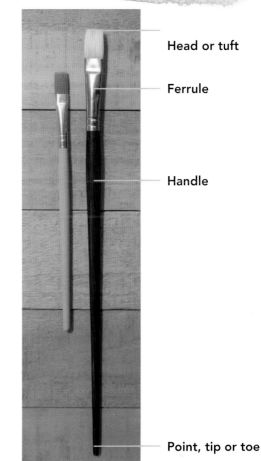

Head or tuft

Ferrule

Handle

Point, tip or toe

## BRUSH CARE

Taking good care of your brushes is an economical move in the long run because they will last longer. For cleaning brushes after working in water-based paints, you can use special brush cleaners and conditioners; however, mild soap and water is an adequate low-cost option.

When working in oil, you can use solvent to clean paint from the hairs or bristles. Some artists clean their brushes with vegetable or baby (mineral) oil instead; it takes time to press out all the paint with this method, but it leaves the bristles soft and conditioned.

After washing your brushes, gently press out any remaining moisture or oil, moving from the base toward the tip. Reshape the bristles or hairs and lay them flat to dry. Store your brushes flat or vertically, handle-end down. Never leave brushes submerged in water or solvent between painting sessions.

# Brush Shapes

**Round Brushes** These common brushes have round ferrules and hairs or bristles that taper to a soft point, along for varying stroke widths depending on the amount of pressure applied and the angle of the brush to the paper. A round brush's large "belly" holds a good amount of moisture, so you don't have to reload with paint as often as with other brushes. This makes a round brush ideal for watercolor and other fluid media.

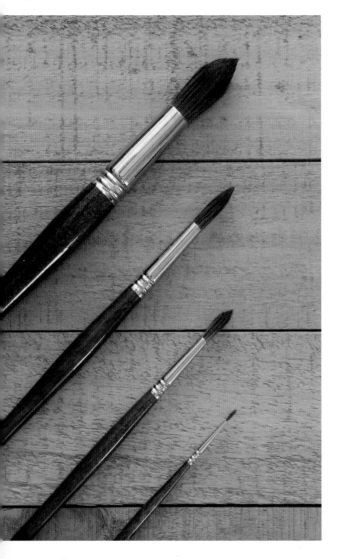

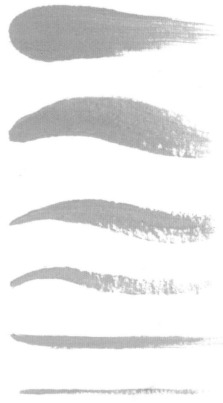

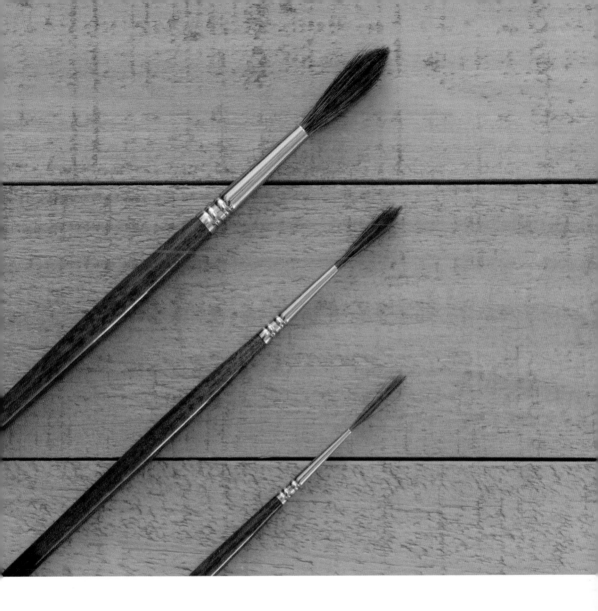

**Rigger Brushes** These brushes have only a few long, soft hairs, making them ideal for thin, unbroken lines. The hairs are not resilient, so it may take practice to use these brushes effectively.

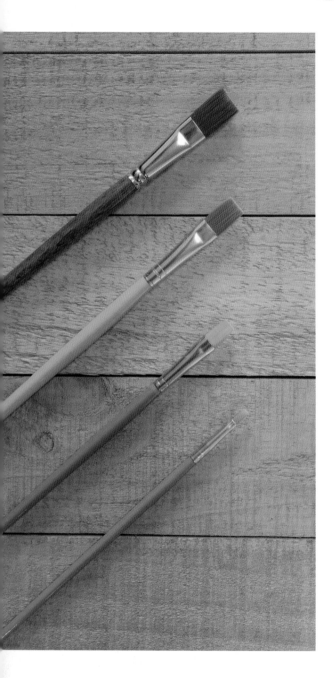

**Flat Brushes** Flats are ideal for creating straight edges and strokes of uniform width. They can also be used edgewise for thin lines or twisted while stroking to create varying widths. Flat brush heads vary in length; the longer the hairs, the longer you can stroke without reloading the brush.

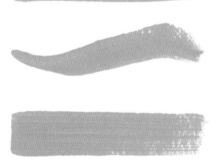

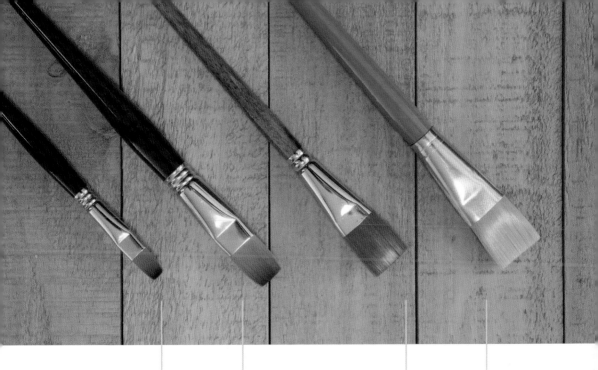

**Bright Brush** These flat brushes have short bristles or hairs, offering greater control over strokes. Brights are great for creating short, chunky, visible brushstrokes.

**Wash Brush** A wash brush is a wide flat brush with soft hairs and a thin edge. It produces thick, controlled strokes for efficiently laying in washes.

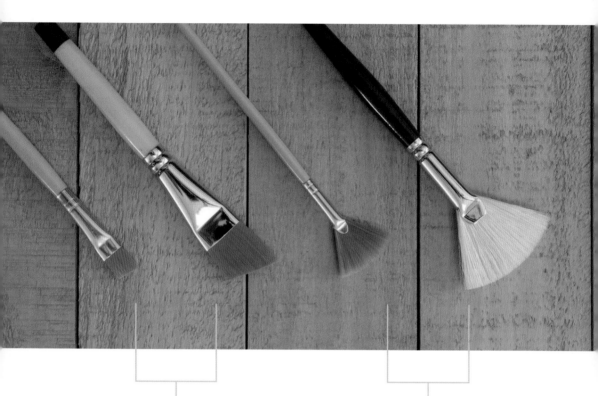

**Chisel Brush** A chisel-edge brush—also called "angular" or "slanted"—is a flat brush with bristles or hairs that have been trimmed diagonally, allowing you to achieve sharply angled strokes.

**Fan Brush** A fan brush features splayed hairs or bristles that are flattened into a curved shape. These brushes are great for loosely dabbing on paint, light blending and light drybrushing.

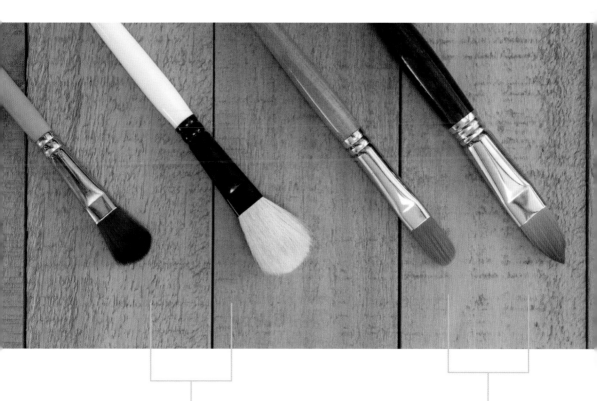

**Mop Brush** A mop brush is a thick bunch of soft hair with a rounded tip. This shape holds a large amount of liquid, making it ideal for laying in and pushing around a loose wash of watercolor.

**Filbert Brush** A filbert brush is a hybrid of the round and the flat brush. The pinched ferrule gives you control over the width of strokes, while the tip feathers to a rounded end.

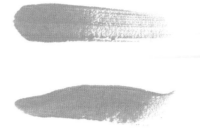

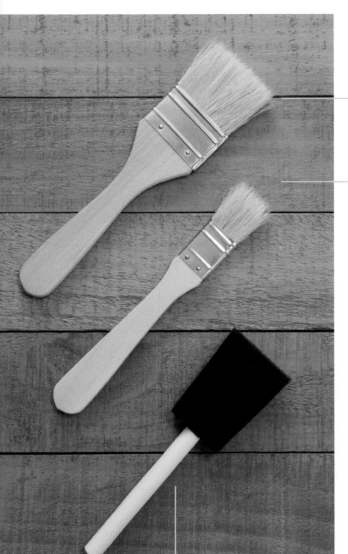

**Chip Brush** A chip brush has a light wooden handle and a head of natural bristles. This sturdy brush is best for creating very rough textures or quickly toning a canvas with textured strokes. Chip brushes are often used for applying adhesives, which is helpful when working with mixed media.

**Foam Brush** A foam brush has an absorbent, spongelike tip that yields smooth, flat paint coverage. Some artists use foam for applying acrylic ground or varnish because it reduces the presence of streaks.

Chinese brush painting has been in existence for more than 2,000 years. Using sheets of silk, bamboo, and other types of wood as painting surfaces, the Chinese created images that were not necessarily accurate or realistic representations of a subject—instead, each stroke simply suggested the spirit and character of the subject. Over the years, the materials and subject matter for Chinese brush has expanded to include watercolor paint—an ideal medium for this style because it allows you to maintain the fluid nature of the art form. Get to know the traditional brushes and tools below.

**Chinese Brushes**  Chinese paintbrushes have bristles that taper to a fine point. This efficient shape combines qualities of both round and rigger brushes, as they can hold a large amount of ink and produce fine detail with their tips. There are two types of Chinese brushes available: stiff hair (also called "wolf hair") and soft hair (also called "goat hair"). Stiff-hair brushes are best for coarse and precise strokes, and soft-hair brushes are great for rendering delicate textures.

**Ink Stick and Stone**  Place one teaspoon of fresh water in the well of the stone. Quickly grind the ink stick in a circular motion for about three minutes, until the water becomes thick and dark black.

**Water Spoon**  Use this tool to transfer small amounts of clean water to the well of the stone.

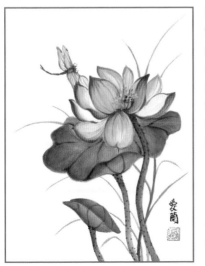

**Brush Rest**  A brush rest is designed to protect bristles between use. If you purchase a ceramic brush rest like this one, place the upper section of the handle (near the tip) on one of the indentations of the brush rest. Never let the bristles stand in water for any length of time, or they will become bent.

*This flower painting by artist Helen Tse is made up of expressive, graceful strokes.*

# Brush Techniques

The following pages show the most common techniques performed with a brush. It's a good idea to practice them on a separate surface before trying them in a work-in-progress.

**Scumble** With a dry brush, lightly scrub semi-opaque color over dry paint, allowing the underlying colors to show through. This is excellent for conveying depth and creating atmosphere.

**Blending** Use a clean, dry fan brush to lightly stroke over wet colors, gently pulling one color into another to make soft, gradual blends.

**Lifting Out** Use a moistened brush or a tissue to press down on a support and lift color out of a wet wash. If using watercolor and the wash is dry, wet the desired area and lift out with a paper towel.

**Impasto** Load your brush or knife with thick, opaque paint and apply it liberally to create texture. This technique can be used to punctuate highlights in a painting.

**Stippling** Using the tip of a brush or knife, apply thick paint in irregular masses of small dots to build color and texture.

**Drybrush** Load a brush, wipe off excess paint, and lightly drag it over the surface to create irregular effects.

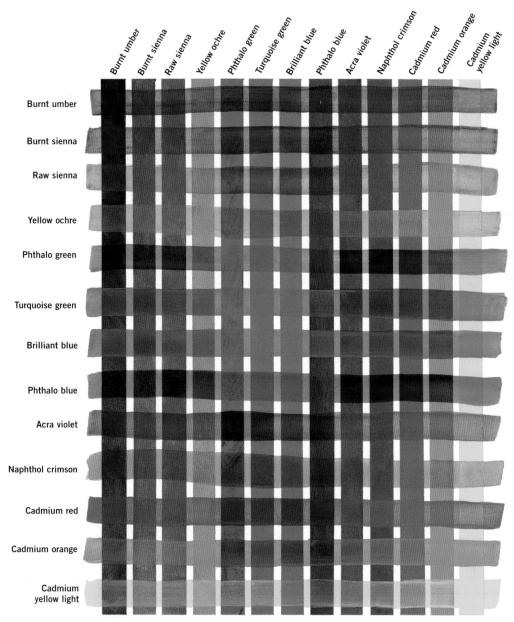

Column headers (top, angled): Burnt umber, Burnt sienna, Raw sienna, Yellow ochre, Phthalo green, Turquoise green, Brilliant blue, Phthalo blue, Acra violet, Naphthol crimson, Cadmium red, Cadmium orange, Cadmium yellow light

Row labels (left): Burnt umber, Burnt sienna, Raw sienna, Yellow ochre, Phthalo green, Turquoise green, Brilliant blue, Phthalo blue, Acra violet, Naphthol crimson, Cadmium red, Cadmium orange, Cadmium yellow light

**Glazing Grid** *In this chart, transparent glazes of 13 different colors are layered over opaque strokes of the same colors. Notice how the vertical opaque strokes are altered by the horizontal translucent strokes.*

**Glazing** Glazes are thin mixes of paint applied over a layer of existing dry color. Glazing can be used to darken, build, or alter colors in a painting. Glazes are transparent, so the previous color shows through to create rich blends. They can be used to accent or mute the base color, add the appearance of sunlight or mist, or even alter the perceived color temperature of the painting. When you start glazing, remember that its better to begin with glazes that are too weak than ones that are too overpowering, as you can always add more glazes after the paint dries.

**Wiping Away** Use a dry brush, soft rag, or paper towel to wipe away paint from your canvas. You can use this technique to remove mistakes or create designs within your work.

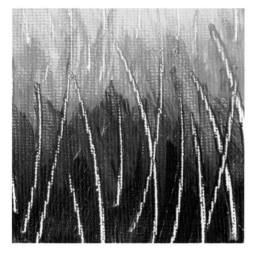

**Scraping** Using the end of a brush handle or the tip of a painting knife, create grooves and indentations of various shapes and sizes in wet paint. This works well for creating rough textures.

**Dabbing** Load your brush with thick paint and then use press-and-lift motions to apply irregular dabs of paint. For depth, add several layers of dabbing, working from dark to light.

**Washes** You can apply washes of any thinned paint; however, they are used most frequently with watercolor. The following pages feature the four most common types of washes.

**Flat Wash** To create a solid, single-color wash, start by mixing a puddle of paint. Fully saturate your brush, and with your painting surface tilted at a slight downward angle, paint a horizontal line. Paint the next horizontal line just underneath and overlapping the first stroke. Continue until you have a flat block of color.

**Graded Wash** This style of wash transitions from concentrated to diluted color, which is great for painting skies. Begin by slightly tilting your art board and saturating a brush with paint. Apply a horizontal brushstroke. Dip your brush in clean water, and dab off the excess water. Now paint another horizontal brushstroke below the first one, slightly overlapping it. The color will begin to run downward. Repeat the last step. Each subsequent stroke will have less paint in it and the pigment will run downward, forming a seamless gradient.

**Two-Color Variegated Wash** You may want more than one color in your wash. For example, sunsets can feature different colors blending into each other. To create a simple two-color variegated wash, start by creating a graded wash following the steps on the previous page. Then turn your art board upside down, and create another graded wash with a different color. Begin on a blank part of the paper and work downward, overlapping the first wash. The colors on the top and bottom of the wash will remain pure, while the colors in the middle will blend.

**Irregular Variegated Wash** For a more "painterly" experience with a large degree of variation and unpredictability, try making an irregular variegated wash. Start by wetting the paper where your wash will go. Using a mop brush, paint one side of the paper, letting the pigment run and fade toward the center. Have fun with it: Dribble a little water on the paint, or place more pigment in some areas. Then tilt the art board around to let the colors run. To the left of this wash, add another color. Let the color mix with your previous wash.

**Wet-on-Dry vs. Wet-into-Wet** In watercolor painting, you can apply your paint to dry paper or wet paper to achieve different effects. Wet-on-dry produces crisp strokes and hard edges, which is great for detail work and a clean, controlled painting style. Wet-into-wet involves soaking the paper thoroughly before applying paint. When the paper has absorbed the water to a matte sheen, stroke paint over the surface and watch it spread to create feathered edges and beautiful blends.

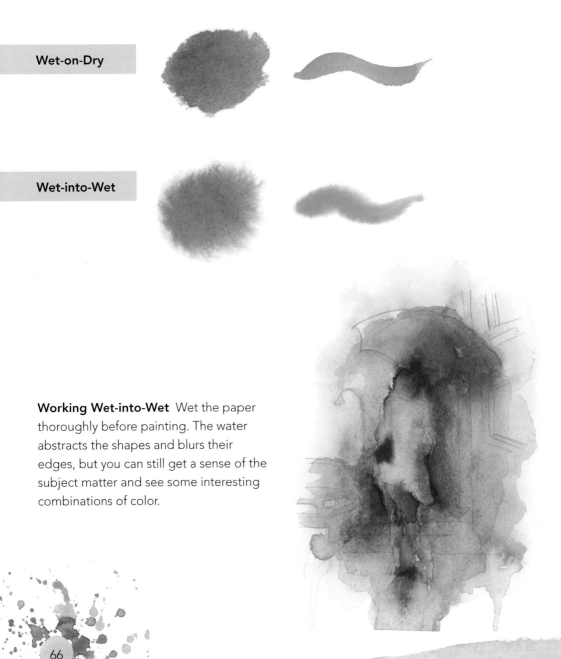

**Wet-on-Dry**

**Wet-into-Wet**

**Working Wet-into-Wet** Wet the paper thoroughly before painting. The water abstracts the shapes and blurs their edges, but you can still get a sense of the subject matter and see some interesting combinations of color.

**Working Wet-on-Dry** This is the easiest method to master. You apply your chosen colors to dry paper and control shapes and boundaries for a clean, crisp appearance.

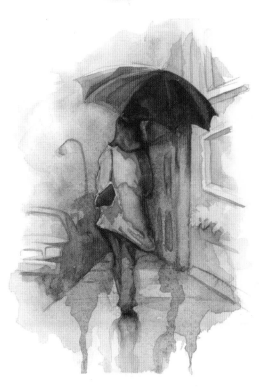

**Working Wet-into-Partial-Wet** This example melds the two methods. The paper is wet when you paint the background colors, causing them to run together. Let the painting partially dry before continuing. Periodically dab clean water here and there to give some of the surface a wet area to blend into, like under the woman's foot and the edge of the umbrella. It has some of the spontaneity of wet-into-wet as well as some control from the wet-on-dry method, making the subject matter more recognizable. Determining the balance between these methods is an ongoing challenge for every watercolor painter.

# Additional Techniques

The paint application techniques on the following pages may not call for traditional brushes, but they are no less exciting. Most of these call for extra materials, but you can find many of them around the house.

**Painting Knives** *Many artists create paintings using only painting knives (see page 69). Artists apply the paint as if they are frosting a cake. This results in thicker, richer applications of paint than with a brush. Holding the blade at an angle to the palette, scrape the paint toward you so it collects on the back of the blade. Spread the paint on your surface, pulling or pushing the knife. You can also apply the paint using dabbing motions.*

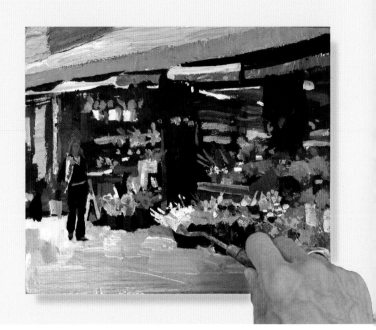

**A**   **B**

*When working with a painting knife, avoid overmixing your paint before applying it to your surface. Leaving mixes loose results in striations and gradations that give your strokes texture, depth, and spontaneity. Compare the flat color of a well-mixed paint (A) with the more interesting strokes of loosely mixed paint (B).*

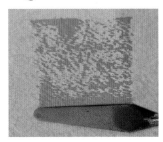

*For this effect, load the back of the painting knife and scrape the paint thinly across the surface for rough, irregular strokes.*

*"Draw" into your paint by scratching with the tip of the knife, revealing color beneath.*

*Some manufacturers offer creative painting knives with interesting edges and prongs. Use these to create exciting textures in your work.*

# PALETTE AND PAINTING KNIVES

Palette and painting knives are tools for mixing and applying oil and acrylic paint. They feature wooden or plastic handles connected to thin, flexible metal blades.

Palette knives (see bottom knife in photograph) have blades that are flush with the handle or slightly bent away. The blade tapers to a rounded tip, and its edges are long and straight. Use a palette knife to mix paints on your palette by scooping and spreading the paint repeatedly.

Painting knives have thin, flexible necks. The blades generally feature a pointed tip and come in a variety of sizes and shapes, including diamond and trowel. The thin neck helps keep your hand out of the paint and responds readily to pressure as you stroke the knife over the canvas. You can apply paint thickly or scrape it across the surface for thin, irregular marks. You can also use the tip to scratch into your paint.

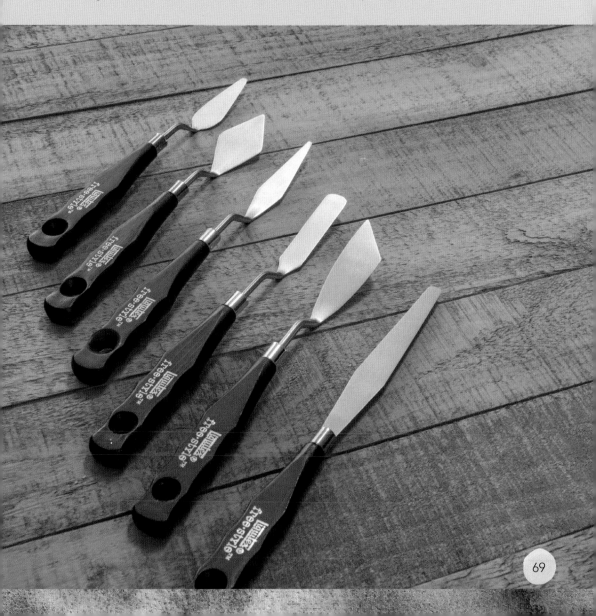

## Using Salt with Watercolor

For a mottled texture, sprinkle salt over a wet or damp wash. The salt will pull the pigment to reveal the white of the paper in interesting starlike shapes. The finer the salt crystals, the finer the resulting texture. (For a similar but less dramatic effect, you can simply squirt a spray bottle of water over a damp wash.

*Artist Maury Aaseng uses salt to create a frost-covered window.*

**Using a Spray Bottle** Spraying water into color can create unique and beautiful textures. Start with a flat wash (A). Then lightly spritz water directly over the wash (B) and notice how the droplets create small textures in the paint. For larger blooms, spray more heavily with water (C).

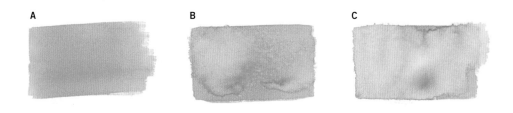

A

B

C

**Using Sponges** These absorbent tools create mottled, irregular textures. Simply dab a small amount of paint onto sponge and use a stamping motion to lightly press the texture onto your support. Build up multiple layers of sponging for even richer textures. Sponges are sold in synthetic and natural varieties. Synthetic sponges come in regular shapes, like circles and squares. Dabbing with this type of sponge creates a more distinct and regular pattern. Natural ocean sponges come in all kinds of shapes and create texture with less-recognizable patterns.

*Unroll the ball of cling wrap, and place it on top of your painting.*

*Press the cling wrap down evenly over your painting. Pull the cling wrap tight and smooth.*

**Using Cling Wrap** Texturing with cling wrap is simple and fun, and it yields beautifully dynamic results. Use it as the focal point of your painting, or use it to provide a mottled underlayer to a more complex painting. In this step sequence, see how the technique is used with alcohol inks.

*Let dry overnight, preferably 24 hours, before removing the cling wrap. Final painting by Cherril Doty and Suzette Rosenthal.*

**Spattering** Spattering can provide a painting with motion and energy. The different methods below reveal different effects. You can use paintbrushes or even toothbrushes for this technique.

*Run your finger along the paint-saturated bristles of an old toothbrush for a variety of dots.*

*Saturate a brush with thinned paint. Then use the handle of another brush to tap the handle of the saturated brush, shaking loose dots of paint on the page. This method is easier to control, and the dots appear more uniform.*

*Run your finger along the bristles of a natural flat or fan brush loaded with thin pain to produce a variety of shapes and widely dispersed dots.*

*While it's possible to use a round brush for this method, the dots tend to disperse in a closer, more uniform pattern of rows.*

*Artist Maury Aaseng uses spattering (along with a spray bottle of water) to create wild splashing in this painting of a foot kicking water.*

**Stamping** Applying paint with stamps creates a crafty, mixed media look in a painting. You can use anything to stamp paint onto your surface, from readily available rubber stamps to a variety of found objects. You can also use natural objects as stamps, such as leaves, seedpods, shells, and feathers. Flattened objects will work best.

*Final stamp painting by Cherril Doty and Suzette Rosenthal.*

**Stenciling** Using a mix of stencils or parts of stencils and punchanella, you can create design and textural effects for your backgrounds. Use a drybrush-and-bounce technique, color mixing, and repetition of patterns to create visual interest.

*Final stencil painting by Cherril Doty and Suzette Rosenthal.*

# Chapter 4:

## Painting Concepts

Knowing the materials and techniques available to painters makes up the first few steps in your artistic journey. But in order to approach a painting with confidence, you'll need a "big picture" view of the entire process. Progressing from basic color-mixing skills and sketches to a polished work of art requires practice and an understanding of standard methods that have been tested and refined by fellow artists throughout the centuries. This chapter covers the following topics:

- Color Theory and Color Mixing

- Drawing Methods

- Painting Methods

# Color Theory

Having a basic knowledge of color and color relationships is essential in learning how to paint. One of the easiest ways to approach color is by seeing it on a "color wheel," which is a visual organization of color hues that follows a logical order around a circle. Seeing the colors organized in this fashion is helpful for color mixing and choosing color schemes.

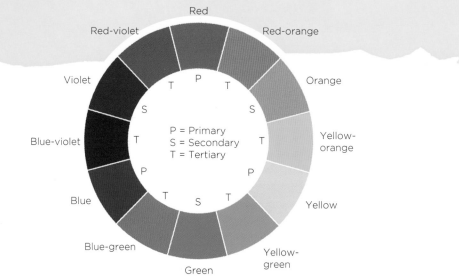

## PRIMARY, SECONDARY & TERTIARY COLORS

The color wheel (also known as the "twelve-hue" color circle) helps us see relationships between **primary, secondary,** and **tertiary** colors. The wheel's three primary colors are blue, red, and yellow, which are arranged at three evenly spaced points around the circle. We can create a multitude of other colors by combining blue, red, and yellow in various proportions, but we can't create the three primaries by mixing other colors.

This color wheel is further broken down into three secondary colors: orange, green, and violet (A). You can create these colors by combining two of the primaries. For example, red and yellow produces orange, blue and red produces violet, and yellow and blue produces green. Also shown in the color wheel are six tertiary colors, which are created by mixing each primary color with its neighboring secondary color. These colors include red-orange, yellow-orange, yellow-green, blue-green, blue-violet, and red-violet (B).

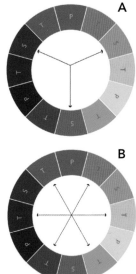

## COMPLEMENTARY COLORS

**Complements** are colors that sit directly opposite each other on the color wheel. For example, red sits opposite green, blue sits opposite orange, and yellow sits opposite purple. These colors are considered opposites in their hues and yield the maximum amount of color contrast possible. Just as white is considered the opposite of black, red is the opposite of green. When complements are mixed together, they form a dull gray, brown, or neutral color. Below are a few tips for effectively using complementary colors in painting:

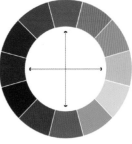

- To lower the brightness or intensity of any color, add a little of its complementary color.
- When placed next to each other, complementary colors will make each other appear brighter and more intense.
- Mixing complementary colors together in varying proportions is one of the best ways to mix colorful gray tones.

## COLOR TEMPERATURE

Artists often refer to colors as being "warm" or "cool." What they are generally referring to is whether a color lies on the red/orange/yellow half of the color wheel, or the blue/green/purple side. The color wheel is arranged so that you can literally divide it in half according to these two groups. The warm side symbolizes the colors of sun and fire, while the cool side is associated with ice, water, and sky. Warm colors appear to come forward, and cool colors appear to recede. An easy way to remember this is by recalling how mountains in the distance take on an increasingly bluish cast the farther they recede.

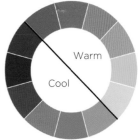

## COLOR PROPERTIES

**Hue** Hue is often used interchangeably with the word "color" and refers to the family to which a particular color belongs. For instance, chartreuse, leaf, and mint green are all in the hue family.

**Saturation** Saturation (also called "intensity" or "chroma") refers to a color's level of brilliance. Highly saturated colors such as phthalo blue and quinacridone magenta are vibrant, whereas colors like yellow ochre and burnt sienna have a lower saturation level and are considered duller colors.

**Value** Value refers to a color's lightness or darkness. A yellow hue is a light value, sometimes called a "high key" value, whereas purple is a dark, or "low key," value. Every color has a corresponding value, which can be altered by adding a darker or lighter color to it.

# Color Mixing

Understanding the various properties of colors and paints—from hue and color temperature to pigment opacity—gives us the power to combine colors effectively on the canvas. With this foundation in place, it's time to further explore the art of color mixing.

## MIXING FOR VIBRANCE

We've learned that mixing complementary colors together yields neutrals, grays, and browns. Now we need to learn the basic ideas behind mixing secondary and tertiary colors according to our needs, whether vibrant or muted. To achieve the most saturated, brilliant secondary and tertiary colors, mix colors that *lean* toward each other. For example, you can mix a vibrant purple using ultramarine blue (which leans red) and quinacridone magenta (which leans blue). Mixing phthalo blue and cadmium red yields a completely different result, as they both *lean* yellow. Because yellow is the complement of purple, the mixture is naturally muted.

Note the differences in chroma between the secondary acrylic mixes at right. On the opposite page, you'll find a color wheel to help you create the cleanest, most vibrant mixtures of primary colors based on the direction they lean. (For more on color mixing, see page 34.)

*The acrylic mixtures at right show an example of vibrant mixing and an example of dull mixing for each secondary color—purple, green, and orange.*

**Vibrant**  **Less Vibrant**

Quinacridone magenta (leans blue) + ultramarine blue (leans red)

Cadmium red light + phthalo blue (both lean yellow)

Phthalo blue (leans yellow) + cadmium lemon yellow (leans blue)

Ultramarine blue + cadmium yellow medium (both lean red)

Cadmium red light (leans yellow) + cadmium yellow medium (leans red)

Alizarin crimson + cadmium yellow medium (both lean blue)

# Vibrant Mixing Chart

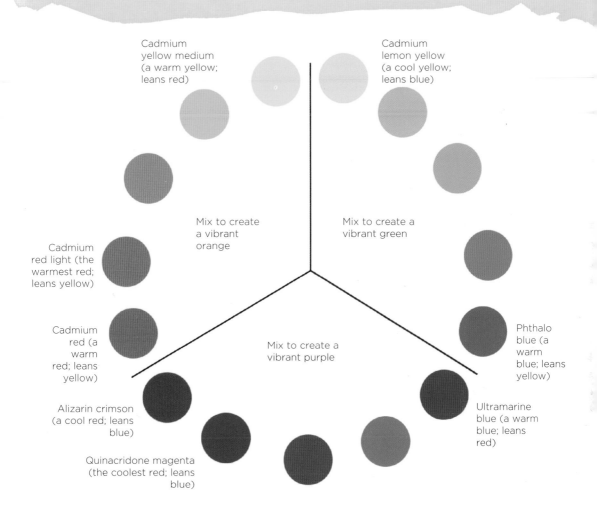

Cadmium yellow medium (a warm yellow; leans red)

Cadmium lemon yellow (a cool yellow; leans blue)

Mix to create a vibrant orange

Mix to create a vibrant green

Cadmium red light (the warmest red; leans yellow)

Cadmium red (a warm red; leans yellow)

Phthalo blue (a warm blue; leans yellow)

Mix to create a vibrant purple

Alizarin crimson (a cool red; leans blue)

Ultramarine blue (a warm blue; leans red)

Quinacridone magenta (the coolest red; leans blue)

To mix the most vivid secondary and tertiary colors from primary colors, use colors within the boundary lines of the pie chart above. For duller mixtures, use primary colors that lie outside of the lines.

# DRAWING METHODS

Many artists choose to first lay in a sketch before applying paint to the paper, ensuring that their subjects are placed accurately within the scene. Artists may work in different methods to arrive at a final sketch for painting; the most common are discussed on the following two pages.

**Classical Drawing** The classical way of drawing involves measuring proportions by eye to lay in their subjects accurately as they relate to each other. Then they build up the forms using basic shapes and volumes, instilling their sketches with a three-dimensional quality. Artist's may create a sketch in this manner using a separate sheet of paper, then transfer it to a painting surface using one of the following two methods.

*View the exercise above by artist Lance Richlin. At top is his rendition of Michelangelo's study for the Libyan Sibyl. At bottom, he has reduced the figure to its most basic forms, exaggerating the shadows and minimizing the surface shading to emphasize the volumes. These volumes represent bumps and bulges that might lie within the body, indicating the underlying structure. Try creating a volume study of your own subject to better understand its forms.*

**Grid Drawing** This method helps you break down a subject into smaller, more manageable segments. Draw a grid of squares over a photocopied image; then draw a corresponding grid over your painting surface. Copy what you see in each square of the line drawing in each square of the painting surface.

*Using a grid of squares as reference points, you can accurately position the features of your subject.*

**Transferring an Image** You can use this method for tracing the main outlines of your reference onto a support. Photocopy or print out your reference at the size you plan to draw it. Then place a sheet of tracing paper over the printout and trace the outlines. Coat the back of the tracing paper with graphite and place the paper graphite-side down on your painting surface. Trace the outlines with a ballpoint pen or stylus. The lines of your tracing paper will transfer to the surface below. (You might also choose to use transfer paper, which already has one side coated in graphite.)

*While tracing the main lines of your subjects, occasionally lift the corner of the sketch to make sure the lines are transferring properly.*

## DRAWING MATERIALS

You can use a variety of materials to draw your sketch on a painting surface. Watercolorists generally use simple graphite pencil, using light, thin strokes that won't interfere visually with the final piece. Acrylic and oil artists can use graphite as well, but many choose to use vine charcoal, chalk, permanent marker, or thinned paint (on a small brush). Remember to keep your sketchmarks light so that a noticeable amount of residue doesn't taint the purity of your paint in later stages. If you choose to use marker, make sure you plan to apply enough layers to cover the lines in the finished work.

*In this acrylic sequence, artist Janice Robertson creates her sketch over a toned canvas using chalk followed by darker, thinned paint. These initial lines do not show through in the finished piece.*

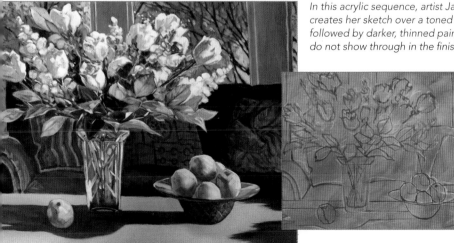

# Painting Methods

As tempting as it is to jump into painting your subject on a blank canvas, it's important to acquaint yourself with time-tested methods. From building a painting slowly in careful layers to more direct approaches, there are a few basic ways to move from start to finish. Let your taste and style help you decide!

## STARTING WITH A TONED CANVAS

Many oil and acrylic artists like to begin by painting their canvas with an overall color. This accomplishes two things: it removes the stark white of the canvas, which can feel intimidating, and it provides a color that will peek through in small areas that have not been completely covered by the final painting. These tiny bits of color help unify the piece, especially when the focal point of the painting—for example, the pink tulips—is a color that is not repeated elsewhere.

*For this painting, artist Patti Mollica began with a mid-value pink tone over the canvas created with acrylic quinacridone magenta.*

Patti developed the scene by applying paint over the toned canvas, building up the subject's forms with shadows and lights.

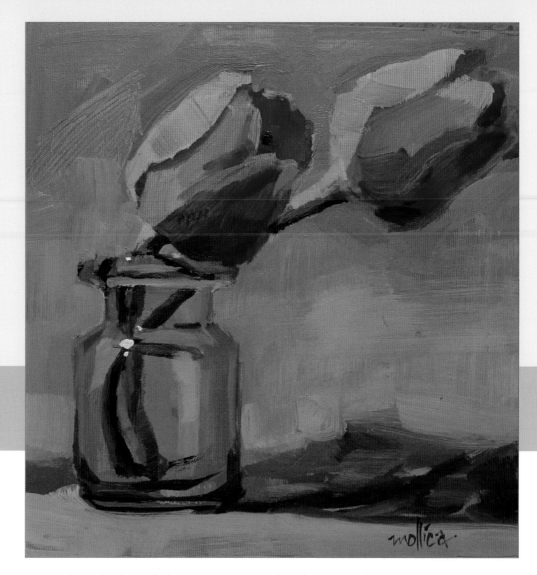

The pink peeks through the gray-green mix that dominates the final background, tying the tulip colors into the whole painting.

## TIP

To make a particular color appear vibrant, surround it with a grayed-down tone of its complementary color. In this case, the pink flower needed to "pop," so Patti surrounded it with a gray that leans green, since pink (red + white) is opposite green on the color wheel. Due to their complementary relationship, the gray-green makes the pink appear more vibrant.

# GLAZING OVER A GRISAILLE

Used in oil and acrylic painting, a grisaille is an underpainting made up only of shades of gray, black, and white to reflect the values of the scene. The artist then applies glazes over the grisaille to build up rich color slowly and deliberately, with each glaze color influencing the colors below. Think of each glaze as stained glass being laid on top of the grisaille.

*For this acrylic painting, artist Patti Mollica created a grisaille underpainting using black acrylic thinned with water. You can also work over a grisalle of pen and ink, charcoal, or graphite; however, if you use charcoal or graphite, you'll want to spray your finished work with fixative before applying paint.*

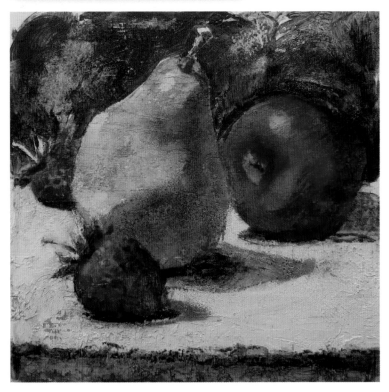

*Patti then built up color using thin glazes of paint. Transparent paint pigments are the best choice for this process. When working in acrylic, you can prepare your glazes using glazing medium to give yourself a longer working time and improve paint flow.*

## TIP

It's a good idea to allow colors to "pool" in and around the nooks and crannies of a textured grisaille. This adds interest to any flat area that may otherwise look dull.

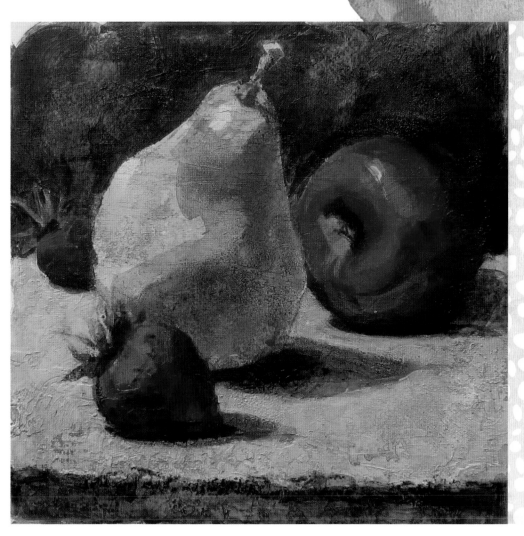

*Paintings created in this method have a luminous quality unlike anything created with opaque pigments because the light shines through the layers of tinted color and reflects back.*

# DARK TO LIGHT VS. LIGHT TO DARK

A common approach to oil and acrylic painting involves working from dark to light, which refers simply to applying the darks and shadows in the beginning stages and leaving the lights and highlights for the later stages. This eliminates the need to apply each intricate shadow individually, allowing you to focus on the illuminated areas and saving brushstrokes in the long run.

Watercolor, however, calls for the opposite approach. As this medium relies on the white of the paper beneath to show a paint's vibrance—and it is difficult if not impossible to remove tone once it has been applied—artists build up layers of watercolor working from light to dark.

*In this sequence, artist Patti Mollica develops an acrylic painting beginning with dark midtones and shadows, slowly building up to lighter, brighter values and highlights.*

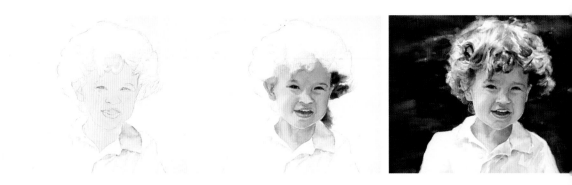

In this sequence, artist Peggi Habets develops a watercolor portrait beginning with light washes of the subject's skin tone, slowly building up to the darker values.

# CREATING THUMBNAILS

One way to ensure that your piece will have a strong composition is to use thumbnail sketches. A thumbnail sketch is a quick, small drawing that helps you plan the arrangement of elements in your painting. Explore different compositions and value patterns until you find a composition that demonstrates a strong, clear expression of the focus of your painting.

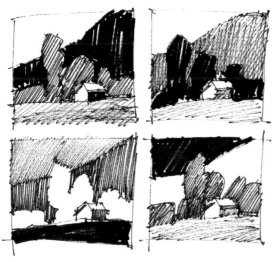

*It's best to use no more than four distinct values for your initial thumbnail sketches: dark, medium, light, and white. After creating a few variations, select the one that is simple with a dramatic value pattern. Among these examples, artist Joseph Stoddard chose the top left thumbnail to use as a guide for his painting.*

*This is the final watercolor painting that resulted from the value thumbnails above.*

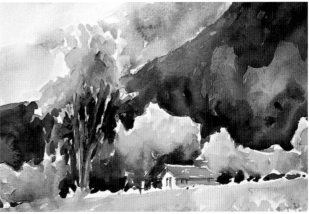

# TIPS

- Work quickly and without detail.
- Establish the values across the composition.
- Make distinct value differences; white, light, medium, and dark.
- Don't just scribble around; be clear with your shapes.
- Try different media, such as pencil, pen and ink, or watercolor.

- After you have developed a value/composition pattern, apply color in a "value sense."
- Follow this as your roadmap for the final painting. The hard decisions have been made—now paint with reckless abandon.
- Finally, don't be a slave to your sketch; if something accidental happens and looks good, go with it.

# Chapter 5:

## Demonstrations

Now that you've prepared your workspace and gotten to know the basics of painting tools and materials, it's time to try your hand at painting. In this group of step-by-step projects, you'll find a variety of styles, techniques, and processes presented by an accomplished selection of artists. This chapter features the following demonstrations:

- Rendering Sunsets (watercolor)
- Creating Wet Reflections (watercolor)
- Shaping with Shadow (acrylic)
- Using an Underpainting (oil)
- Painting a Landscape (oil)
- Building a Guitar (mixed media)

# Rendering Sunsets
## WATERCOLOR WITH PAUL TALBOT-GREAVES

For sheer color indulgence, there is nothing quite like a sunset. I often take to higher ground where I live to study them. Winter sunsets are my favorite, as the colors tend to be clearer than they are during summer. This painting reflects the eastern colors of a sunset over a body of water.

### PALETTE
alizarin crimson
burnt sienna
cobalt blue
French ultramarine
light red
Naples yellow

## STEP 1

Sketch the scene and prepare for a wet-into-wet wash by wetting the paper. Use a 1" flat brush to apply clean water evenly to the paper. When the sheen on the paper has disappeared, add another layer of water and brush it around as before. Once the finished sheen has a satin appearance, apply paint. Use Naples yellow where the sky is lightest, following up with varied washes of alizarin crimson and cobalt blue. Keep your strokes loose to achieve soft sky shapes. Then create the general reflection in the water using the same colors.

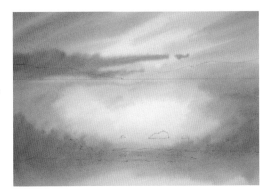

## STEP 2

As soon as the previous washes are dry, mix cobalt blue with alizarin crimson and paint the distant hill at right. Then mix French ultramarine with light red and paint the dark hill at left. This mix is stronger in value, bringing the hill on the left closer to the viewer than the other hills.

## STEP 3

Using a medium round brush, use cobalt blue and alizarin crimson to paint ripples in the water. Use a controlled side-to-side motion with the brush, making the ripples smaller as you move into the distance.

## Step 4

Now paint the dark stretch of foreground using French ultramarine and burnt sienna. To make the wash more interesting, mix the colors on the paper so that a little of each color shows. Then add the rocks and seaweed bits using the same foreground colors. Finally, with a diluted mix of the same wash, apply the soft reflections of the rocks.

# CREATING WET REFLECTIONS

## WATERCOLOR WITH MAURY AASENG

Painting wet-into-wet causes the colors to bleed and create soft, undefined edges while still holding their basic positions. This gives the painting the watery look of a reflected landscape. As you follow this demonstration, and as you create your own watery landscapes, remember that a landscape over water often reflects the features and colors of its surroundings.

### STEP 1

Begin by painting from back to front. Wet the sky, paint a little blue in the top right corner, and let it bleed downward. Create the autumn foliage by working on one section at a time. On your dry paper, switch back and forth between light and dark, letting the colors overlap and mix to create variegated washes. The light colors dominate the top of the page, and the bottom features darker colors.

## STEP 2

The next-closest feature is the bridge. Develop this section by applying a variegated wash, moving from cooler tones along the underside of the railing to slightly warmer neutrals as you progress downward. Then paint various colors for the rocks' shadows.

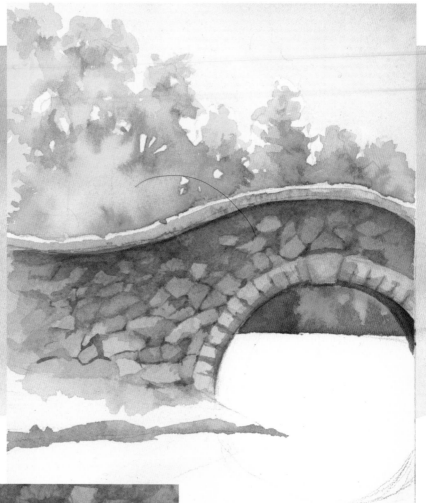

## Detail

Paint shadows in negative space between the rocks to give the bridge texture and form. The darkest shadow should be the underside of the arch.

## STEP 3

To create the illusion that colors fade as objects recede into the distance, use more concentrated pigment as you move into the foreground. Using an angled brush, paint the foliage in front of the bridge using a wet-on-dry technique. The green and red trees provide contrast and focus the viewer's eyes. Create a lightly colored wet-into-wet wash for the various shades of grasses, and paint vertical, irregular strokes below the trees.

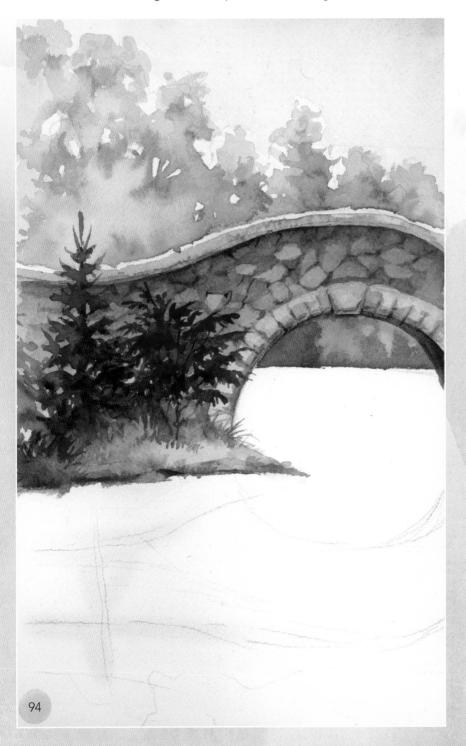

## STEP 4

Now create the reflection in the water. First, dampen the entire page using a flat synthetic brush. Painting from background to foreground, and lightest value to darkest value, roughly paint the colors from the landscape into the water below. The colors and shapes don't have to be exact; they should just correspond.

Finally, while your paper is still wet, run a small, flat, slightly damp brush in streaks across a few areas of the water to create waterlines and subtle detail. Remember to stop before you overwork your painting! The pigment flowing in the paint creates beautiful effects that can be destroyed with too many details.

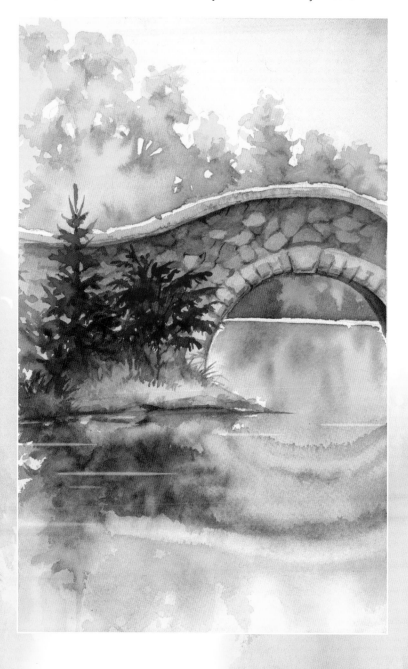

# Shaping with Shadow

## ACRYLIC WITH VARVARA HARMON

Pastry chefs can create frosting flourishes with a flip of the wrist. With just a little practice, you'll be able to paint them with the same ease. The trick is to focus on the shadows. When you learn to place highlights and shadows appropriately, subjects take on dimension and a lifelike appeal!

### PALETTE
alizarin crimson
burnt sienna
titanium white
ultramarine blue
yellow ochre

## STEP 1

Work out this fairly simple composition directly on a small canvas (such as an 8" x 10") using a ¼" flat brush. To establish the color scheme, use yellow ochre for the cakes, mix in burnt sienna for the cup, and apply alizarin crimson and ultramarine blue for the frosting.

## STEP 2

For the background, work from top to bottom, starting with a mix of ultramarine blue and titanium white. Transition to burnt sienna with a bit of alizarin crimson for the lower half.

## TIP

Keep some old brushes on hand, like this small round brush. Although it has lost its shape, the bristles are perfect for applying specks of yellow ochre and white to represent dappled light.

## STEP 3

Using the same brush, paint the cakes—including what will be the liner—starting with mostly yellow ochre on the left, facing the light, and gradually adding more burnt sienna on the right as the cakes move into shadow.

## STEP 4

Next add highlights to the top of the cake on the left (see tip on page 96). Define the paper liners with the ¼" flat brush. At the top of each paper ridge, I apply a mix of yellow ochre and titanium white.

## STEP 5

You have two options for the frosting. (See page 98 for an alternative approach.) Here, with the ¼" flat brush, each swirl is painted individually. Begin with a medium-tone mix of ultramarine blue, alizarin crimson, and titanium white. On top of this, apply shadows, using less white in the mix. Then define highlights, using white with a touch of ultramarine blue.

# FROSTING DETAIL

**A**

You also can approach the frosting as one shape. Mix a medium tone of ultramarine blue, alizarin crimson, and titanium white to add guidelines showing the direction of the swirls. Then paint from left to right, using less white as you move into shadow.

**B**

Next add more dimension to the swirls with shading. I use the same mixture from the previous step, but with more white. I also add more alizarin crimson for a pinkish tone in the lighter areas on the left and more blue for the darker shadows at right.

**C**

The last step is to add highlights along the ridges of the swirls where the light hits the frosting. I use pure titanium white for the spots where the light hits directly, but I add ultramarine blue to tone down the white for highlights in the areas of heavier shadow.

## STEP 6

When you've finished frosting one cake, move on to the next. Try approaching the frosting on the cupcake in the foreground with individual swirls and the frosting on the cupcake in the background as a whole. Both methods yield frosting that looks good enough to eat. All we need now is sprinkles!

## STEP 7

Dot each sprinkle into place with a medium-tone mixture of alizarin crimson and titanium white, using a small, round brush. To give the dots shape, add shadows and highlights.

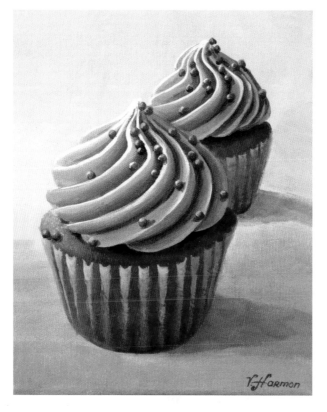

## STEP 8

The sprinkles aren't the only decorations that cast shadows; the frosting also casts a shadow on the top of each cake. Return with a little yellow ochre mixed with burnt sienna to add these. To finish, emphasize the shadows cast from the cupcakes on the table, layering on alizarin crimson mixed with burnt sienna and a little titanium white.

# Using an Underpainting

## OIL WITH CAROLINE ZIMMERMANN

Although the traditional approach to underpainting is to use hues similar to the color of your subject, you can also achieve unique, incredible results by doing just the opposite! Try toning your canvas with this type of underpainting, using colors that may not even exist in the scene you're rendering. You'll be amazed by the beautiful effects these hues help you achieve!

## PALETTE

alizarin crimson
cadmium yellow light
cadmium yellow medium
dioxazine purple
Indian yellow
lemon yellow
magenta

phthalo blue
phthalo green
quinacridone pink
sap green
titanium white
transparent orange
ultramarine blue

### STEP 1

To create an underpainting that will contrast with the greens and blues of this tropical scene, use a mix of alizarin crimson, dioxazine purple, Indian yellow, transparent orange, and magenta. As you'll dedicate the top 2/3 of the canvas to the sky, add more orange in the sky area to complement the blue that you'll add in future steps.

### STEP 2

First mix alizarin crimson with a little dioxazine purple and a few drops of solvent. Then, using a medium bright brush, sketch the composition, establishing the horizon and the lines of the palm tree's trunk. Make dots where you will place the ends of the leaves, and connect the dots to create the palm's shape.

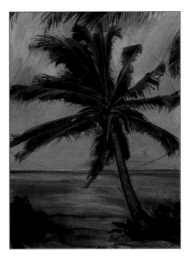

## STEP 3

Begin with the darkest areas of water at the horizon, using broad strokes of ultramarine blue with dabs of phthalo blue and phthalo green. Work toward the shore, mixing in tints of phthalo blue and green and gradually adding white as the water becomes more shallow. Paint the sand and any bits of flotsam on the beach using white mixed with transparent orange, Indian yellow, and dioxazine purple. Add dark colors to the foliage of the shrubs with a mixture of ultramarine blue, dioxazine purple, and sap green. Block in the dark parts of the clouds with a mixture of dioxazine purple, ultramarine blue, and a little white; then outline the general cloud shapes.

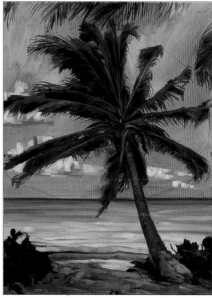

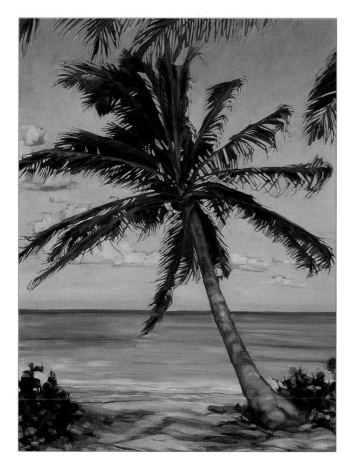

## STEP 4

Mix one part ultramarine blue to three parts white and just a dab of phthalo blue. When painting the sky, "cut in" around the palm leaves, meaning that you can create the shapes of the leaves by painting the sky around and between them. Next, add more variation to the color of the water using light blue mixtures of phthalo green and phthalo blue. Paint the dark areas of the palm leaves with sap green mixed with alizarin crimson, allow the painting to dry before moving on.

# PAINTING THE PALM LEAVES

**A**

While the paint is wet, block in the palm leaves by removing paint instead of adding it. To do this, clean your brush with solvent, blot it on a rag, and lift the color away to indicate where the highlights will be. This is a forgiving technique for indicating lighter areas without the mess of adding white paint.

**B**

Create the shapes of the palm fronds by painting the sky and clouds in and around them. Then use a small flat brush and short, deliberate strokes to create the tips of the leaves. Start at the center of the branch and stroke outward, lifting your brush at the end to create the sharp point.

**C**

Now indicate the undersides of the palm leaves (in shadow) using a dark mixture of sap green and alizarin crimson. (Render each individual leaf with this color.) Then paint the top sides of the leaves, continually adding more sap green until there is very little red pigment left in the mixture.

**D**

Next, add the highlights using sap green mixed with varying amounts of each yellow color in your palette, plus transparent orange and white. Alternate between dark and light to define the details of the branches. Bring the lightest whites of the clouds into the leaves with the same cutting technique used previously.

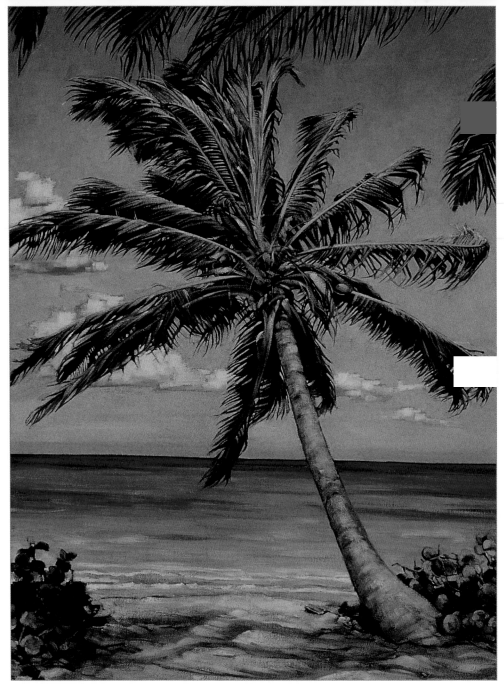

## STEP 5

Paint the center of the tree, using curved strokes to suggest the round shape of the trunk. Apply the brightest highlights of the leaves, trunk, sand, water, and clouds at the very end of the painting so that these elements seem to shimmer in the tropical sunlight. Finish the painting by applying a glaze over the entire surface to unify the painting and adjust some of the colors. Then coat the entire painting with a clear glaze of medium, rubbing away the excess with a flannel rag.

# Painting a Landscape

## OIL WITH JIM MCCONLOGUE

This 30" x 40" vineyard painting is a combination of reference photos from a trip I took recently to Napa Valley, California. I used one photo for the sky, another for the vineyard, a third for the background hills, and a few more for the buildings. Don't be afraid to use artistic license in your own artwork!

## PALETTE

| | |
|---|---|
| alizarin crimson | dioxazine purple |
| cadmium orange | sap green |
| cadmium red light | titanium white |
| cadmium red | ultramarine blue |
| medium | yellow ochre |
| cadmium yellow | |

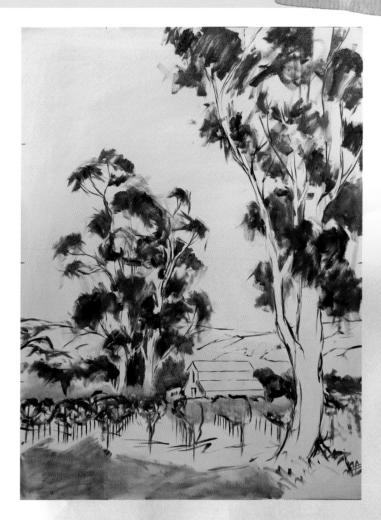

### STEP 1

Begin by toning the canvas with yellow ochre and cadmium orange. Then carefully sketch with paint, using a No. 4 bright brush and a warm brown mix of dioxazine purple, alizarin crimson, and cadmium orange. Alternatively, you can create your drawing with a pencil; however, a brush yields a much more expressive line quality. Oil paint is a wonderfully forgiving medium, and you shouldn't be afraid to simply wipe off passages that are not quite right. Block in larger dark areas with a No. 8 flat bristle brush.

## STEP 2

Begin blocking in some general color notes and value relationships around the sunlit barn. Establish a starting point around the main center of interest that you can use to base the rest of the painting upon. The darker green is a combination of yellow ochre, ultramarine blue, sap green, and alizarin crimson. Add more yellow ochre and a touch of cadmium orange for a nice middle value green.

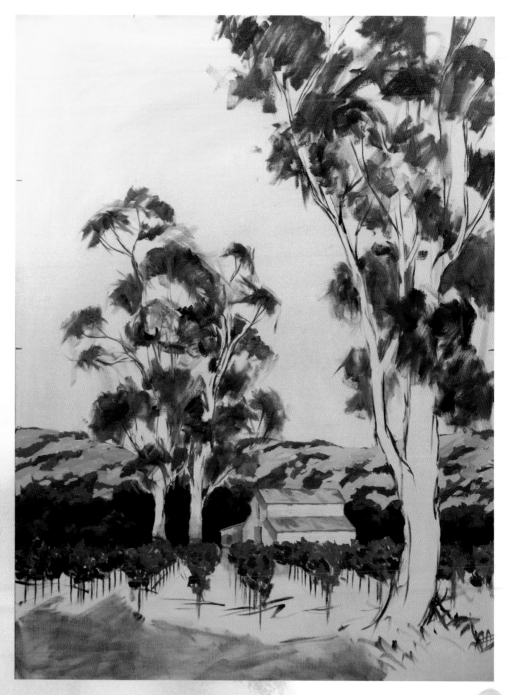

## STEP 3

Then begin to roughly establish the foreground plane and play with the color and shape of the shadowed portions of the eucalyptus tree. The vineyard soil is quite a bit redder than that of the surrounding hills. Combine yellow ochre, cadmium red medium, and titanium white and paint a basic tone that you can adjust once you develop the rest of the painting. It's good to get some paint down and begin the process, knowing that you can add highlights and accents to achieve your desired outcome. Mix blue and purple shadow colors for the eucalyptus by adding ultramarine blue, titanium white, and alizarin crimson to the initial brown mix.

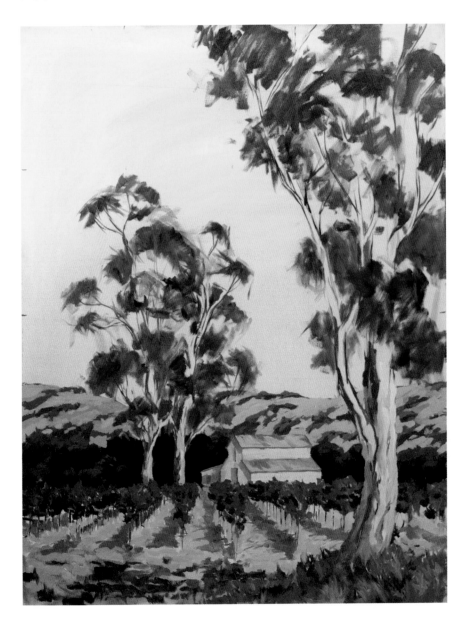

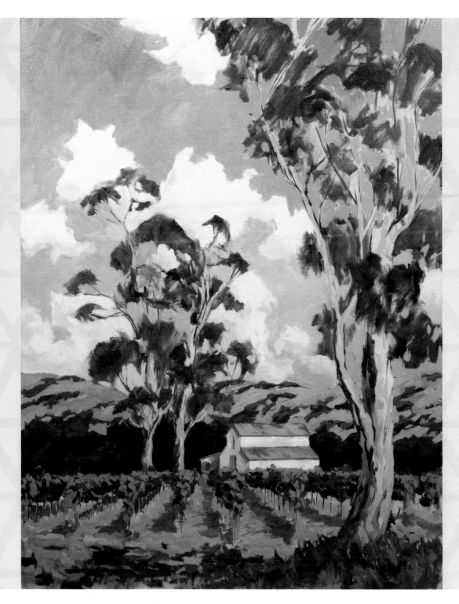

## STEP 4

Paint the sky and clouds, moving more quickly and trying to let the brush bounce and dance. Use ultramarine blue and titanium white with a tiny bit of the foreground dirt color to paint the sky (the brown knocks down the brightness). Add more white and a touch of cerulean blue to paint the light sky near the horizon. For the clouds, use a mixture of titanium white and yellow ochre. Pay attention to the edges of your clouds. (I like mine to melt into the sky in places and be sharper in others. I prefer clouds with a bit more personality, not ones that look like cotton balls!) Add a bit of cadmium red light to the cloud mixture to paint the shadowed clouds.

## TIP

Save enough of your sky color to paint "sky holes" in the tree foliage when your painting nears completion.

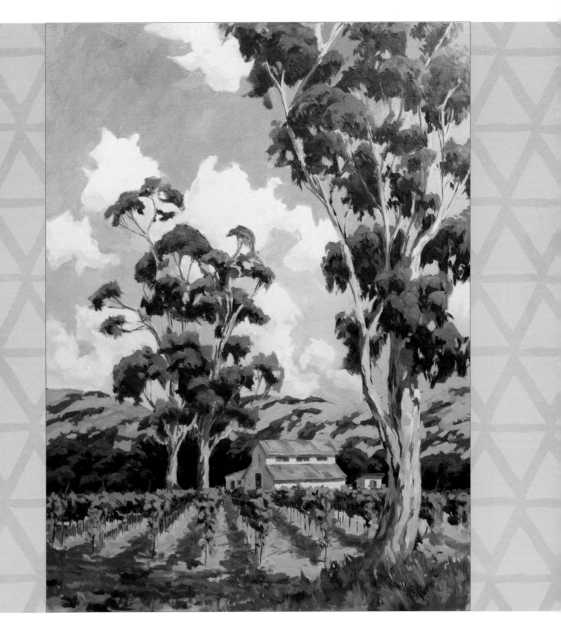

## STEP 5

At this stage, you are about 90% finished. Revisit the barn, adjusting the perspective a bit and adding more features, buildings, and equipment. Drop the roofline slightly, if necessary, and add more vineyard leaves to the foreground to help sink the barn into the landscape. Further develop the foliage of the eucalyptus trees and add highlights, using a bit of cadmium orange and yellow ochre to give the trees a warmer feel.

## STEP 6

Rework the background hills by graying down the trees and adding subtle shifts in color to the warm ochre grasses—adding a bit more red and white in various places to give it some life. Lighten and brighten the vineyard leaves a bit by adding cadmium yellow and a touch of titanium white to the green mixture. Add highlights to the foreground grasses and a few dark accents to the foreground eucalyptus. Perform a bit of negative painting to add sky color to the foliage in spots where the sky peeks through the leaves. Do the same on the foreground tree shadow with a bit of the ground color peeking through. Finish with some lighter, low-key green highlights on the middle-ground trees.

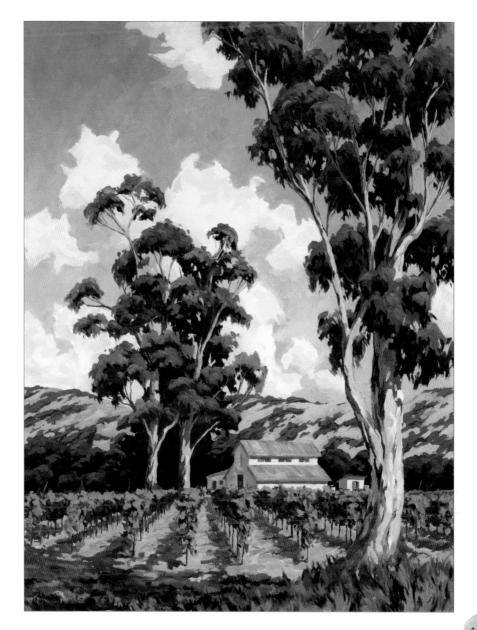

# BUILDING A GUITAR
## MIXED MEDIA WITH JENNIFER MCCULLY

You can use images from just about anywhere in this mixed media painting! Find images on the Internet, in magazines, or make photocopies of your favorite CD covers. Simply get creative, and be inspired by your favorite songs, bands, instruments, and musicians!

## SUPPLIES
- 9" x 12" or 11" x 14" canvas
- Music-related images, scrapbook paper, and magazine images
- Mod Podge
- Pencil and eraser
- Acrylic paint (various colors)
- Black watercolor pencil
- White and black watercolor crayons
- Black oil pastel

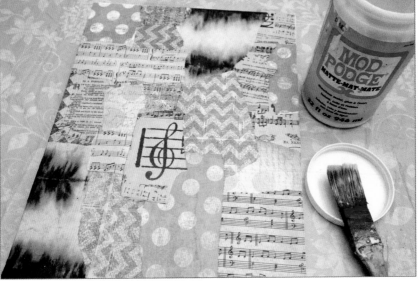

### STEP 1
Cut or tear out images and papers, and arrange them on the canvas. Glue them in place with a layer of Mod Podge. Apply another layer of Mod Podge on top, pressing into place so the edges don't curl up. Let the canvas dry.

## STEP 2

Use a pencil or watercolor pencil to draw the outline of a guitar. Keep it simple! Your outline can appear rather sketchy, and that's okay. You'll cover most of the sketch when you start adding color. Just be sure the outline is dark enough to see.

## STEP 3

Use your finger to start adding color to the background. You can use a paintbrush for this step, but I like to use my finger because it gives me more control. Don't completely cover the background images with paint—just a thin coat will do!

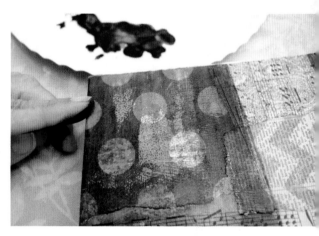

## STEP 4

When the background is done, do the same with the guitar. Avoid putting any paint in the center of my guitar so the natural color of the images shows through.

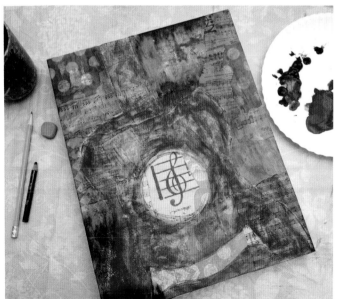

## STEP 5

Let the paint dry. Then outline the guitar with a black oil pastel. Smear the pastel by rubbing your finger along the outline. This softens the outline so it doesn't look too perfect or bold.

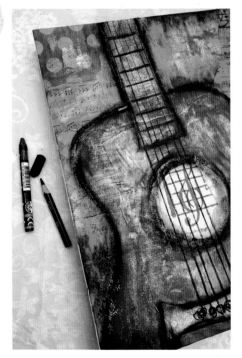

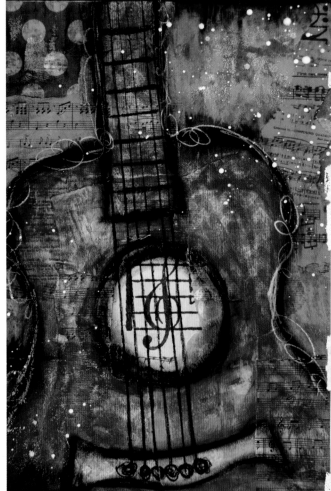

## STEP 6

For the final touches, add paint splatters in random places on the edges. Then add a squiggly white outline around the guitar with a white watercolor crayon.

# CONCLUSION

The end of this book is only the beginning of your artistic journey. Learning the fundamentals prepares you to forge your own path; never stop experimenting and building your tool set. Get messy, take risks, and make personal discoveries!